Couples

Couples

A Celebration of Commitment

Portraits by
M. I. HAMBURG

Text by
CATHERINE WHITNEY

Andrews McMeel
Publishing

Kansas City

00 01 02 03 04 TWP 10 9 8 7 6 5 4 3 2 1

Library of Congress Cataloging-in-Publication Data
Whitney, Catherine.
 Couples : a celebration of commitment / text by Catherine Whitney ; portraits by M. I. Hamburg.
 p. cm.
 ISBN 0-7407-1005-2 (hard)
 1. Married couples—United States—Psychology. 2. Married couples—United States—Attitudes.
 3. Commitment (Psychology)—United States. I. Title.

HQ536 .W522 2000
306.872—dc21 00-035674

Photograph of Mort and Joan Hamburg © 2000 by Doug Liman

Attention: Schools and Businesses

Andrews McMeel books are available at quantity discounts with bulk purchase for educational, business,
or sales promotional use. For information, please write to: Special Sales Department, Andrews McMeel Publishing,
4520 Main Street, Kansas City, Missouri 64111.

To my mother, Sadie Hamburg. She always hoped that I would become a lawyer and marry well, both of which I did while she was still alive. She also encouraged me to "take pictures" and maybe someday become a photographer, "if that's what you want to do, but *after your children are grown up.*"

I also dedicate my work to Arnold Newman, the finest portrait photographer ever.

M. I. Hamburg

To my parents, Richard and Janet Schuler, who always made it clear to their nine children that, through all the ups and downs of a fifty-year marriage, they were very glad to be together, and happier still that we were along for the ride.

Catherine Whitney

Contents

Contents

Contents

Acknowledgments

THE CREATION OF this work depended on the contributions of many people. From the start, it has been a collaborative effort. We would like to give very special thanks to our agent, Jane Dystel, who recognized the inspirational power and the market potential of a book dedicated to couples and commitment.

Jane found the perfect home for the book at Andrews McMeel Publishing. We are deeply appreciative that our editor, Jean Zevnik, and senior editor, Chris Schillig, were so enthusiastic about the project from the start. Jean has nurtured the book along with professional care and insight.

Of course, we owe a debt of gratitude to all the couples who contributed their time, energy, and honesty to making this book so special. We are certain that their efforts will prove deeply meaningful for the many couples and couples-to-be who will be granted a glimpse into their lives.

In addition, each of us would like to offer the following personal thanks:

M. I. Hamburg:

I am grateful to and acknowledge the talents and dedication of Lyle Kahn and Paul Whitney, my photography assistants. I am also very thankful to Alan Goldberg of Modernage Photographic Services, Inc., in New York, for his great help in selecting, cropping, and printing each portrait.

I want to give sincere thanks to all the representatives, administrative assistants, producers, and sec-

retaries whose gracious persistence and willingness to jump through many scheduling hoops made the portraits and interviews possible.

I would like to acknowledge Barbara Dafoe Whitehead, whose book, *The Divorce Culture,* was my initial inspiration for this undertaking.

I know I would never have had the courage to be involved in this project were it not for my wife, Joan, and my wonderful children, Elizabeth and John, who supported me at every turn. I will be grateful to them for as long as I live.

Catherine Whitney:

I am, as always, very thankful to Paul Krafin, my partner in writing and in life. Paul was instrumental in helping to make these couples resonate on the page. He makes daily life pretty colorful, too.

I want to acknowledge the important contribution of Lynn Lauber, who helped shape the direction of the text in its initial stages, and who contributed to the crafting of an effective proposal.

To my family and extended family, from coast to coast—thank you for being a positive reminder in my life that there is always a place to come home to.

Photographer's Note

IN LATE 1998, as my wife, Joan, and I approached our thirty-ninth year of marriage, I came upon an intriguing book by Barbara Dafoe Whitehead called *The Divorce Culture* (Knopf, 1997). As its title implied, the book presented some discouraging data about the extent to which divorce has become entrenched in the American way of life. Although Ms. Whitehead did not exactly sound a death knell for the institution of marriage, she warned that the ease and frequency of divorce made it more difficult than ever for couples to summon the necessary commitment to stay together through time and adversity.

Ms. Whitehead's book sparked something in me. I began to think about my own marriage, and I wondered why it had remained so strong over such a long period of time. Later, I asked Joan what she thought had kept us together. As we talked about our marriage, we realized that we were not exceptions to the rule. Most of our friends had also been married for a long time, and they seemed to still enjoy being together. Even those who had been divorced had, for the most part, remarried. We agreed that people were naturally drawn toward marriage and commitment.

That being the case, we wondered why so many of the young people who we knew—including our very accomplished daughter and son—did not seem eager to make the lasting commitment that had meant so much to us. Perhaps the divorce statistics, which still hovered at around 50 percent, served as something of a self-fulfilling prophecy, by giving the impression that commitment was a nearly insurmountable goal.

I decided I wanted to do something that would provide inspiration and optimism to young people regarding the great joy and countless rewards that come from a long marriage. At the time, I was pursuing a new career as a professional photographer after nearly forty years as a communications lawyer. My law career had been intensely satisfying, giving me the opportunity to serve as CEO of two communications companies, write three books on communications law, and teach at the New York University School of Law. Now, with Joan's full support, I had turned a lifelong passion for photography into a full-time vocation, and with some success. A show of my work had just been held at the Elaine Benson Gallery in Bridgehampton, New York, in May.

It was somehow natural that my fascination with committed couples would merge with my photographic pursuits. That is how the idea for *Couples: A Celebration of Commitment* came to life. I would portray, through film, the faces of commitment—thirty-five couples who had forged that special bond. In addition, each couple would be interviewed and brought further to life in text by Catherine Whitney, a well-known nonfiction writer, who agreed to collaborate on the project. Together, the photographs and text would begin to answer the question that lived in so many hearts and minds in this age of separation: Why do some couples stay together happily while so many others are breaking apart?

I decided to use the natural setting of the couples' homes or apartments—and, occasionally, their offices. I shot the portraits with a Mamiya RZ67 (6x7) camera, set up on a tripod, employing natural light where I could, and using one strobe light and a light box when needed. I also used a Nikon 90S (35mm) camera, with an indirect flash, which allowed me to take a variety of photographs around the location.

There is no single way to convey love and commitment, and each couple brought their own unique style to the photo session. While some cuddled and kissed, or wrapped their arms around each other, others were more casual and less demonstrative. The result is a terrific mix of very individual relationships, in which the love and commitment is plain to see. The other quality that comes through in the photographs is an abiding sense of optimism. It is my fervent desire that men and women who are contemplating a lasting commitment now or in the future will look into the faces of these couples and see everything they someday hope to be.

—M. I. Hamburg

Introduction

LET US NOT TO THE MARRIAGE OF TRUE MINDS

ADMIT IMPEDIMENTS. LOVE IS NOT LOVE

WHICH ALTERS WHEN IT ALTERATION FINDS,

OR BENDS WITH THE REMOVER TO REMOVE:

O, NO! IT IS AN EVER-FIXED MARK,

THAT LOOKS ON TEMPESTS AND IS NEVER SHAKEN . . .

William Shakespeare
Sonnet 116

IN OUR HEART of hearts, we all long for commitment, and seek the "ever-fixed mark." Even the most fiercely independent, the painfully shy, the inwardly driven, the emotionally crippled, the physically distant—all of us. It is an instinct deeper than desire, a force more profound than attraction, a need as pure as oxygen.

Commitment is more than an act of love; it is an act of faith. And it is faith that keeps love aloft, holds it high above the floodwaters of bored indifference by the application of a tenacious will. Couples, once together, *want* their bond to last. Yet in our restless, mobile culture, commitment is one of the hardest states to negotiate and preserve. Marriage vows no longer assure it; no legal contract can protect it. In these days of easy divorce and endless possibility, it often eludes us, but even the most hardened and cynical nonbelievers cannot resist the urge to scan every crowd looking for that special someone who will prove them wrong.

No one really fears commitment; it's like fearing the light of day. We fear breaking apart, not com-

ing together. Perhaps those who harbor the most fear are also the most fragile. Discord makes them crumble, struggle sends them fleeing. They bring upon themselves what they dread the most.

How can some couples survive staggering challenges, year after year, while others seem barely able to make it through their first fight? We all want to know if there is a sure path to commitment.

WHAT IS THE SECRET?

Mario Cuomo, the former governor of New York, told me a story about his wife, Matilda's, mother. "She was one of the smartest women I ever knew," he said, "and she had something to say about why so many marriages fail. She said—mind you, this is translated from her incredibly colorful English-Italian— she said, *'People think you're supposed to be happy.'*"

He smiled with satisfaction when I laughed. I imagine he had told the story many times before, and the response was predictable. The unspoken caveat was *"all the time."* People think you're sup- posed to be happy all the time, as if the wedding ceremony were a sprinkling of fairy dust.

Everyone wants to know if there is a secret to a successful marriage. As I interviewed the couples in this book, I collected little gems like Governor Cuomo's, examining them for clues. I often asked couples to define their own special formulas for success, and mostly got variations of all the familiar themes—no secrets at all: attraction, of course; respect, humor, flexibility, compromise, intimacy, shared values—I could go on. If I were simply to catalog these insights in a list, you would find nothing sur- prising—not a thing you didn't already know.

So if everyone already knows what it takes to have a successful marriage, why does success seem so hard to achieve—so rare and remarkable when you see it? The response to that question has already filled enough volumes to circle the earth many times. Clearly, *knowing* is not enough. Each couple writes its own story.

Usually, that story begins with attraction—the indefinable "something," the spark. I found it inter- esting that twelve of the men I interviewed (and none of the women) specifically remembered falling in love at first sight, and thinking, "I'm going to marry that woman." Another detail, though I won't speculate on its meaning, is that six of the men remembered the women wearing red dresses at the time.

"There she was, a tall, beautiful blonde, in a red dress," rhapsodized one man. "The rest is history."

That history, draped so casually across the arm of "the rest," involved forty years, two children, several different careers, an illness and recovery, and a couple or three life-changing events.

Bill Moyers claimed he fell in love with Judith while staring at the back of her head, as he sat behind her during a college exam. For the record, Judith doesn't believe him. She thinks he was just looking over her shoulder so he could copy her answers.

I suspect the men who declare today that it was love at first sight then are reliving the moment through the prism of all they've since come to know and appreciate about their wives. They remember the attraction because they feel it still, but the truth of their love lies somewhere in the fertile terrain of "the rest."

Recently I read an interview with the actor Michael Douglas in which he described falling in love with the actress Catherine Zeta-Jones, his current fiancée who is expecting the couple's child. He said that he hadn't known her before he saw her in the movie *The Mask of Zorro*, but as he watched her on the screen, he found himself desperately attracted to her. So great was his obsession that he decided no obstacle would stand in the way of his meeting her and convincing her to go out with him.

I found this story vaguely disquieting. Most of us "fall in love" with characters in movies at one time or another. It's what directors and actors want to have happen. I suppose if you or I were to then track down the actor who portrayed our fantasy and declare our obsession, we'd be called stalkers. Healthy people understand that what we see on the screen is not real. I'd think Michael Douglas, an actor himself, would understand that more than most. Who was the object of Douglas's attraction? Was it Catherine, a woman he didn't know? Was it a character in a movie who was not real? Or did he just like the way her eyes danced and her bodice heaved?

Rabbi Peter Rubinstein of Central Synagogue in New York observed that the language of attraction contributes to the perception that we are helpless to control its course. "We talk about *falling* in love, as though it were an accidental event," he said. "We can't control the fall. The problem is, once we get our bearings, we can climb back out of it, and that's just what many people do. When you take the element of *volition* out of the picture, the significance of love is diminished."

A flame of desire might get you through the night, but it doesn't get you through the years. For that, you need extra layers of attraction, which require cultivation in the brain.

When I interviewed couples, every single one mentioned that having a sense of humor was essential to a happy marriage. "He makes me laugh." "She's so funny." In the setting of our conversations, I could see it was true. Couples laughed, joked, and teased, aptly demonstrating their point.

But while everyone talked about the importance of humor, I wondered if people fully examined what they meant. If a sense of humor is really so high on the list of what people are looking for in a mate, why are so many couples—at least the 50 percent of married couples who get divorced every year—grim, fearful, angry, hurt, bored, and jealous? What happens to those great senses of humor? Send in the clowns!

Humor can mutate into hostility. It can be cruel. It can be worn as armor to avoid intimacy. It can trivialize our concerns. For while we want a partner to have a sense of humor, we want even more to be taken seriously.

And what of compromise? Every relationship requires it, yet the bending of one will to accommodate another is fundamentally an unnatural act. Compromise presumes inequality, as one person must sublimate his or her will to the other. Sometimes the compromise lasts months or even years. When Geraldine Ferraro married John Zaccaro, she agreed to a big compromise: She would stay home with the children while they were young. John, in turn, promised to be supportive of Geraldine's career choices once she returned to work. John Zaccaro certainly got more than he could ever have bargained for when Geraldine Ferraro became the first female vice presidential candidate in the history of the United States. But the agreement worked for them both, because their fundamental values and goals were the same.

Commitment requires not only compromise, but tolerance. Unless you marry your clone, there are bound to be endless, niggling little differences that can grate on you, irritating you like a pebble in your shoe. The difference that came up most often with these couples was the desire of one partner (usually the woman) to be sociable, and the desire of the other (usually the man) to stay home, read, watch TV, listen to music, brood, and eat.

Mario Cuomo observed, somewhat morosely, "To be married, you have to learn to do things you hate doing. Matilda loves going out. She's the quintessential social creature. She walks into a room, she smiles, they go, 'Ah, Matilda's here, let's have a party.'" He sighed. "I've had to accommodate that side of Matilda."

Judge Judy Sheindlin, who remarked that her husband, Jerry, would never initiate a phone call or

a dinner date with friends if left to his own devices, joked, "I tell Jerry he has to see his friends occasionally, if only so there will be someone willing to attend his funeral."

Still, with all the differences, everyone agreed that there had to be some core of commonality. Opposites might attract, but being married was another matter. The commonality didn't necessarily lie in backgrounds. Some couples grew up in similar environments, while others did not. We all know couples whose credentials are perfectly matched—from background to education to religion to color preferences. When they divorce on the grounds of "incompatibility," we can only shake our heads in wonder as the "perfectly matched" couple complains, "He doesn't understand me." And "She's not on my wavelength."

The writer Richard Reeves told me a story about a female friend who liked to go out with men who were fifteen or twenty years younger than herself. One evening Richard saw her at a party, and she was with a much older man. Richard asked, "What's going on? What happened to all the young men?" She replied, "I'm not going to do that anymore." When a surprised Richard asked why, she said, "I got tired of explaining the Korean War to them." Ultimately, it helps to have the same worldview.

Perhaps that's where values come in. When people talk about having shared values, they're usually referring to the big stuff. The core beliefs and ideals. That's why you find the majority of couples belonging to the same political party, or at least being mutually tied to none of the above; sharing the same faith or lack thereof; and being guided by the same principles about raising children. But God—or the devil—is in the details. Two people can have exactly the same values when it comes to raising their children, but they may disagree vehemently on how to achieve them. Values are the content we give to life, not a predetermined set of guidelines. In the end, each couple must wrestle with how their values play out in the light of each ordinary day.

When a marriage begins to fail, it is like being overcome by a virus that appears from nowhere. One minute you're healthy, the next minute you're sick. The source of the virus is not visible, you can't pinpoint it. It may have been germinating for months or years before you feel it. The same is often true of marriage. People say, "We fell out of love," or "We grew apart," the process so gradual as to be invisible. We have as vague a grasp on why we break up as we do on why we stay together. Yet, as a rule, we are much more curious about those who break up than we are about those who stay together.

When the broken apart and the flashily divorced capture our attention, it is easy to overlook the

successes—the enduring bonds of couples of every persuasion who, without fanfare and despite all odds, remain together. Yet, in their understated manner they are quite fascinating for no other reason but this: They managed—sometimes in callow youth—to find the companions who would accompany them throughout the whole terrain of their lives.

It's a remarkable achievement—"miraculous," as one couple put it. A couple devoted to each other in mutual admiration and respect is beautiful to behold. It can restore belief in the Platonic notion that there is another soul in the world who can be one's other half. But there is more than romance going on in the lives of committed couples. In the couples we interviewed, we have seen something tenacious and levelheaded and clear-eyed, as if they are imbued with a special toughness of spirit that allows them to transcend disappointment and life's daily trials. But are they really extraordinary, or are they an example of what all couples might be? Our culture is saturated with the bitter intrigue of scandal and the explosive dispersion of relationships. Perhaps we should pay more attention to the successful models, the harmonious unions that have endured.

RECURRENT THEMES

In the end, a successful marriage becomes the unique invention of every couple who lives it. However, it is possible to detect some common qualities, imaginatively expressed and specifically observed. Let me tell you a little something about these couples.

They're Individuals First Individuals attract. Not *opposites*, individuals. The love that lasts is not narcissistic. It does not seek its own reflection in the eyes of the other. These couples are made up of individuals, and it is their individuality that allows them to fill in the blanks in each other's lives. The journalist Steve Roberts recalls something his father used to say: "You know, separately your mother and I are very flawed people, but together we make a good team."

The glue that holds them might be called compatibility, but it seems to be more colorful than that word implies. As the legendary songwriter Adolph Green put it in describing his marriage to Phyllis Newman, "Sometimes we can be miserable, and other times we have tremendous fun. Don't you think that's better than plain old compatible?"

They Never Shut Up If you're trying to find a happy couple, look for the ones whose mouths are moving. The couples in this book are not just talkers—they are *driven* to talk. When Matilda Cuomo describes the long conversations she and Mario had during their courtship, it sounds as if she's describing the richest, most heavenly dessert. Most of these couples courted with words, and even though the words themselves weren't always that romantic, the conversations were suffused with romance. And they're still talking after all these years. "Imagine being with someone you have nothing to talk to about," marveled Letty Cottin Pogrebin, whose thirty-six-year marriage to Bert has been a nonstop conversation. She equates it with friendship. "Think about it. People go to great lengths to find friends they can talk to—people who challenge them. We have it home grown."

Clive Chajet, noting that he and Bonnie are nonstop talkers, said it is the greatest sign of an authentically together couple. "You can fake love," he said, "but you can't fake like."

They Relish a Good Fight While we're on the subject of talking, these couples are not afraid to fight, either. On his wedding day, the writer Richard Reeves said of his relationship with Catherine O'Neill, "I have fought more with this woman in the last year than I have fought cumulatively with other people in the rest of my life." And then he married her.

What about never going to bed angry? "Ha!" laughed Letty Cottin Pogrebin. "We don't believe in not going to bed angry. We have a rule. Go to bed angry. Sleep on it." Other couples subscribed to a sentiment once expressed by the comedian, Phyllis Diller: "Never go to bed mad," she said. "Stay up and fight!"

The key word is *stay*. Avery and Judy Corman, married thirty-two years, observed that during every crisis, they survived because at least one of them was not willing to throw in the towel. "If one person has a foot out the door, but the other one is saying, 'I'm not ready to call it quits,' you'll hold on," Avery said. "If you both say the hell with it at the same moment, then you're in trouble."

They're More Expansive Than Insulated The theme "You and me against the world" is a familiar one in songs and stories. Marriage is supposed to provide a shelter against the danger and turmoil

on the outside. Yet, the recurring theme of these couples is not that marriage has protected them from the world, but that it has motivated them to take on the world.

Gail Sheehy and Clay Felker had an on-and-off relationship that spanned seventeen years before they made the commitment to marry. What finally brought them together for good was their mutual love of an orphaned refugee girl. They found themselves when they reached out to embrace her.

Often, it seemed, the happiest couples were the most expansive. Leonard and Evelyn Lauder share not only their time and resources; the love they have for each other reflects outward to those who need it.

They Cheer Each Other On Most of these couples are of a generation when wives were expected to be the head cheerleaders for their husbands' professional success. So it's not surprising that the women in these marriages have been supportive. What is remarkable is how thrilled the husbands are with their wives' achievements—even when they surpass their own.

"It takes a very secure man to love his wife's success," said Dan Gasby, who is married to B. Smith. Jerry Sheindlin put it another way. When asked if he felt threatened by Judy's newfound fame, he laughed. "Are you kidding? I'm married to a very rich woman. What could be the problem?"

They Know the Meaning of "For Worse" Every once in a while you come across a couple who exemplifies the meaning of "for better or for worse." Christopher and Dana Reeve are such a couple. They are two beautiful, smart, successful people, whose world was shattered in a second. Everything that visibly identified their union was gone. Yet they have become the model for commitment—even optimism—in the face of "the worst."

Sometimes a couple has the good fortune to escape the worst times. Steve and Cokie Roberts say of their marriage, "So far we've lived for better, not worse; for richer, not poorer; in health, not sickness. We've been incredibly blessed." However, they're careful to add that the future is an open road. Anything can happen.

Most of us bump up against walls that shake our universe. What is "for worse"?

Is it discovering, as Bill and Judith Moyers did, that their beloved son was a heroin addict?

Is it watching your hopes and dreams dissolve when your young husband is diagnosed with cancer and is not expected to survive? That happened to Ruth Bader Ginsburg.

Is it the numbing pain of public judgment, and unfair rebukes, the awful spotlight that shined on Geraldine Ferraro and John Zaccaro for many years?

It's probably different for everyone. Whatever form it takes, it serves as the crossroad, and those who choose to go on are strengthened by it.

They're Not Done Yet A spirit of optimism pervades the lives of these couples. They can't begin to imagine what lies ahead, but they're eager to take the trip. Matt Mallow, a very settled and happily married corporate lawyer, said, "At this point, I can't imagine changing course, much less starting over. And yet, I recently visited my eighty-two-year-old mother. Her eighty-four-year-old second husband died recently, and they'd been married forever. And now she has a new boyfriend. So you never know."

You never know. Commitment is a potion mixed of equal parts mystery and reality. Remarkably, we have been given the chance to experience it.

—Catherine Whitney

Couples

JUSTICE RUTH BADER AND MARTIN GINSBURG

Passionate Pursuits

WHEN RUTH BADER GINSBURG emerges from a back room of the Watergate apartment she shares with Martin, her husband of forty-six years, she might be stepping out of a portrait—so much does she resemble in real life her familiar Supreme Court visage. If anything, her small frame is thinner than usual, her eyes behind the signature glasses a bit wider. Three months after surgery for colorectal cancer, she is juggling an exhaustive series of weekend chemotherapy treatments with a full weekday court schedule.

At first glance, Ruth and Martin appear to be one of those couples most distinguished by the ways they differ. She is reserved and quietly elegant in a stylish black pantsuit, her hair tied back in a ponytail. He is casual and irreverent, a devilish grin spreading across his cherubic face. The tantalizing smells of his latest gourmet creation waft in from the kitchen. But one soon learns that things are never as they seem in the Ginsburg household. You couldn't guess that the affable Martin is a preeminent tax attorney—a longtime advisor to many business giants, including Ross Perot, who endowed a chair at Georgetown Law School in his name. Or that Martin's skill in the kitchen is seriously refined, a match for the great chefs of Europe. (He added culinary studies to the rigors of law school shortly after his new bride served her first meal—a memorably inedible tuna casserole.)

Ruth produces her share of surprises too. In spite of a voice so soft that listeners must lean close

to hear, she is witty and engaging. At James Madison High School in Brooklyn, she belonged to the Boosters Club and was a Twirler—a high-spirited side the public rarely sees. Ruth is unabashed in her devotion to Martin, and he to her.

"It's like Kabuki Theater here," Martin says cheerfully, comparing their lives to a highly stylized form of Japanese drama in which reality is masked and costumed.

Also Trivial Pursuit. This is a couple that likes to debate the nuances of every question. Martin's way is to poke and prod. Ruth, not surprisingly, is as rigorous as a court justice, who knows the damage a misplaced fact or an idle word can do—even in private conversation. She forms her thoughts carefully and is very precise in her language. When you see them together for a while, the Ginsburgs' compatibility is quite visible, and somewhat touching. They are adept at filling in the blanks of each other's lives.

They met as students at Cornell, when Martin was eighteen and Ruth was seventeen. What Ruth remembers most vividly is how much they talked—which was akin to oxygen in the airless environment in which young women of her era dwelled.

"Marty was the only one who cared that I had a mind," she says. "In those days that was unusual. I remember one of my girlfriends saying, 'You're so lucky.'"

Ruth was grateful to have Martin, but it still dismayed her that so many others did not take her seriously. She remembers that even some of her professors in law school thought she was attending so she would have a better understanding of her husband's profession. In spite of the fact that Ruth made law review at both Harvard and Columbia, and graduated tied for first in her class at Columbia, she could not find a job in her profession after graduation. Remembering the humiliation of that period, she says, "Not a single law firm in the entire city of New York bid for my employment." Being a woman–especially a Jewish woman, and a mother to boot—was an insurmountable hurdle. She was recommended for a clerkship with Supreme Court Justice Felix Frankfurter, but even he said he wasn't ready to work with a woman as law clerk.

Ruth ultimately accepted a position teaching at Rutgers, but institutional barriers did not disappear. When she became pregnant with the couple's second child, Ruth wore baggy clothes to mask her condition. In those days, a pregnant teacher could be required to leave her job without the right to return.

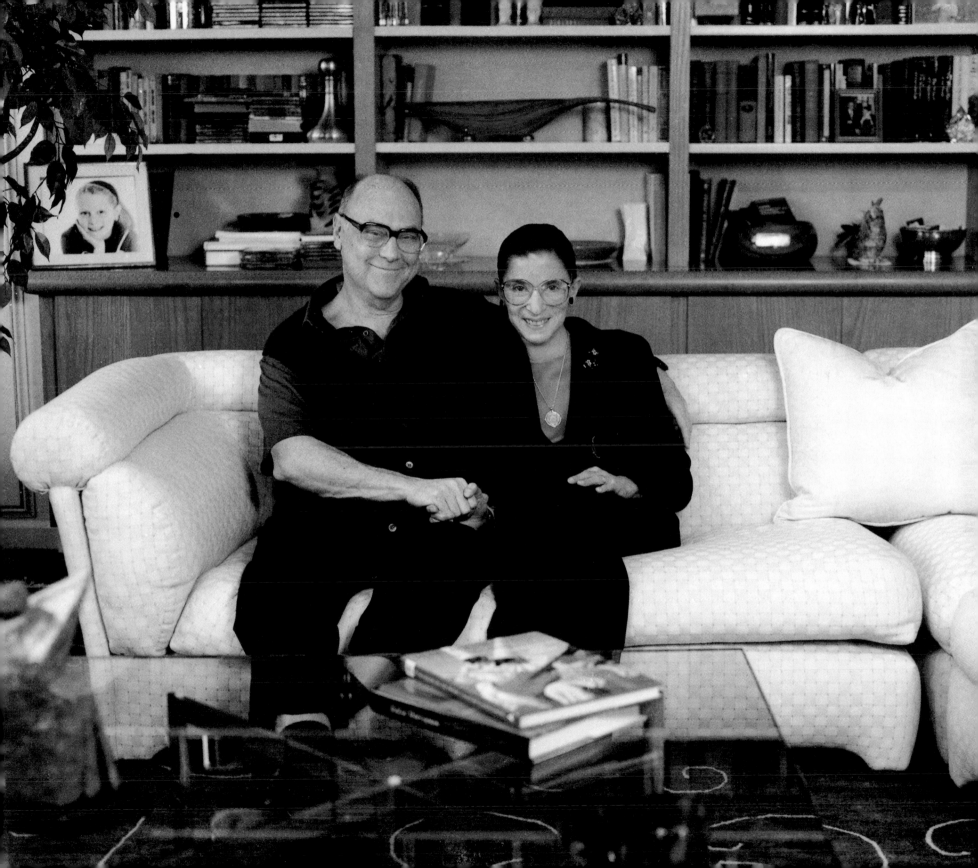

The outside world was an unfriendly and restrictive place for a woman of Ruth's intellect and drive. At home, however, she and Martin created a rarefied environment—one of equality and shared commitment. Martin was a full partner in child raising, and he did more than his share of the cooking. They raised their children—a daughter and a son—to achieve, and provided a model that made achievement possible.

Cancer has been the ghost hovering in the background of their lives. Ruth's mother, Celia Bader, died of cervical cancer in 1948, the night before Ruth was to graduate from high school. At her swearing in as a Supreme Court justice, Ruth delivered a moving tribute to her mother—with an eye on her daughter: "I pray that I may be all that she would have been had she lived in an age when women could aspire and achieve, and daughters are cherished as much as sons."

Early in her marriage, there was a cancer scare with Martin, too. While Martin was still in law school, he was diagnosed with testicular cancer, a rare and often fatal disease. Ruth prepared herself for the possibility that she might have to support the family alone. It was a terrible time for them, but Martin recovered.

Now there is Ruth's cancer. It came upon her unawares—as colon cancer often does—stopping her in her tracks. While she was in the hospital, Martin never left her side. He held her hand through the night, just as she had once held his so many years before. If force of will and perseverance are the keys to survival, Ruth and Martin have that and more.

Their devotion shines through. "When I get up to give a speech," Ruth says, wrapping her fingers through Martin's, "the first thing I do is search the room until I find Marty's smile. Then I'm fine."

RABBI PETER R. AND
KERRY RUBINSTEIN

Creating the Sacred

A RABBI AND A former Presbyterian were seated across the aisle from each other on an airplane when the rabbi said, "Why don't you come and sit next to me." If this sounds like the opening to a tall story, in a sense it is. It's also a true story.

The year was 1992, the day was Easter Sunday, the place was a nearly empty early-morning flight from San Francisco to New York. Rabbi Peter Rubinstein, chief rabbi of New York's prominent Central Synagogue, was seated in seat 2A. He was returning to New York after visiting his son. Since moving east after his divorce, he had faithfully made the trip every four to six weeks.

Across the aisle, in seat 2C, was a slender, pixie-faced woman, staring with deep concentration at the screen of her laptop computer. Kerry was also divorced, and her work as a management consultant kept her on the road almost constantly. She had logged nearly a quarter million miles in the past year.

Peter remembers every detail of that flight, beginning with the instant he braved an opening remark. "We were flying over a place that only Californians know, called Mono Lake, and it was an absolutely exquisite day. As often as I had flown this route, I still loved to look at it. I especially loved Mono Lake, because I used to go camping there, and I had wonderful memories of that place. And I turned to Kerry and I said—absolutely brilliant line—'God, what a beautiful day.'" He grimaces, a little embarrassed to remember the moment. In spite of his position, the rabbi has a charming air of

self-effacement. He doesn't really mind exposing his nervousness or his emotional insecurity. In fact, he's eager to talk about the happy chance of that flight.

Peter's remark opened a conversation, and the two began to talk. When Peter then suggested to Kerry that she come and sit next to him, Kerry closed her computer and obliged. They spent the next couple of hours talking about everything—well, almost everything. Peter had deftly managed to avoid the subject of his profession.

When the flight attendant announced the start of the movie, *Father of the Bride*, Peter got nervous. "Kerry, I don't watch movies when I'm flying," he admitted. "It's because I tend to cry if it's anything emotional—and I would hate to start crying on you. Usually it's because I'm tired, and I've just left seeing my son. And of course, *Father of the Bride* is not the movie to watch."

Kerry was a bit taken aback by Peter's burst of emotion, and she wondered about this stranger. When the movie came on and, true to his word, he started crying, she *really* wondered. Then he took her hand.

"I was so mad at myself," Peter remembers. "I had just met this woman, I was crying, and holding her hand, and I was transported back to high school. You know, when you're on a date, and you're holding a girl's hand, and you're frozen. If you move your hand, it means something. If you take your hand away, it means something. I was stunned at what I was doing. So I did the only courageous thing I could, which was to say I had to go to the bathroom."

Peter escaped to the tiny bathroom and tried to gather his wits. As shocked as he was by his behavior, he was also discomfited by the awareness that Kerry still had no idea he was a rabbi. It was about time he told her the truth. He returned to his seat, cleared his throat, and said, "Kerry, there is something you should know about me. I'm a rabbi."

Kerry jumped up—but she wasn't, as Peter feared, fleeing. She went to her seat, grabbed her laptop computer, and returned. "I have to show you my five-year plan," she said excitedly, as she booted up the computer.

Peter watched, transfixed, as Kerry located the file. She pointed. "You see, right here it says, 'Find my spiritual path.' And number two is 'Develop a long-term relationship.' And number three is 'Find a community.'"

"I was impressed by the fact that she would intentionally state the need to be in community as

well as in a personal relationship," Peter says. "For me, the congregation was my life, and all personal relationships existed in the context of the community. But I would not have expected her to say that."

The intensity of their conversation, over the five-hour flight, was such that before they landed, they both felt a strong bond. But Peter was aware they could not have a relationship.

"I just want you to know," he told Kerry regretfully, "that although I'd love to see you and socialize with you, I will not date anybody who is not Jewish."

"I understand," she said. "But I come to New York a lot. Maybe we can have dinner or something once in awhile."

That was fine with Peter. Dinner was different than dating. So whenever Kerry was in New York, they would get together. Sometimes on a Saturday morning, Kerry arrived during services, and sat in the back of the synagogue. Soon, she found herself being caught up in the solemnity, the beauty of the music, the visceral aura of spirituality. Like many of her generation, Kerry had long been on a search for spirituality that had been absent in her Protestant upbringing. In California, she had studied Zen Buddhism, with its focus on achieving inner peace through meditation. But she was not comfortable with Buddhist theology, and she certainly hadn't given much thought to Judaism. So here she was, feeling such a remarkable sense of belonging. She posed the question to Peter, "Can I study this?" He referred her to a rabbi who was conducting classes, and without any fanfare, Kerry began a two-year road to conversion.

Peter was pleased, but because they had grown so close, he feared that Kerry was doing it for him, not for herself. He finally broached the subject, saying, "I want you to know that just because you may convert, that doesn't mean we're going to get married." To which Kerry replied, "I'm more certain about being a Jew than I am about marrying you."

It was plain to everyone around them that Peter and Kerry were in love. When a friend of Peter's, a Catholic nun, teasingly accused him of being smitten, he tried to deny it. But the truth was, he had reached the point where he felt he could not be—did not want to be—without her. "One day, I asked myself, if I were to say good-bye to Kerry now, how would it feel?" he says. "And I couldn't imagine it. It made me sad just to think about it. I realized, especially since she had converted, that this was just meant to be."

Now Peter had to face the congregation. He knew his congregants were happy for him. As Kerry

joined him more often at the synagogue, people came to know and like her. Still, as Peter knew, Jews don't always do well with converts. So perhaps there was a wait-and-see attitude among some of the congregants. However, their wedding day, in the presence of more than one thousand friends and congregants, was a joyful celebration, and everyone welcomed Kerry enthusiastically.

Peter has counseled enough couples from mixed backgrounds to know that there are special challenges. Although Peter and Kerry's union was not an intermarriage, since Kerry converted, the differences in tradition were still there. Intermarriage is an issue that Peter has often wrestled with. Indeed, it remains a matter of some controversy, even within Reform Judaism.

"Often couples will come to me," he says thoughtfully, "and they'll tell me, 'Look, I didn't choose to fall in love with somebody who's not Jewish, but I did. We love each other, and I think we have a better chance of having a successful marriage than I had with the man I was seeing before, who happened to be Jewish.'

"I would be less than honest if I didn't tell such a couple that, statistically, there are more breakups among intermarried couples. However, intermarriage can mean different things. It can mean a Jew and a Christian, but most Jews do not marry Christians. Most Jews marry non-Jews. The difference is that the people they're marrying are not actively living as Christians. If they were actively living as Christians, it might be more difficult. So, the challenge is to help them figure out how they're going to live and raise their children. If they don't resolve the issues with children, they're not going to make it. Truthfully, conversion is the ideal. But there are couples for whom conversion does not happen, who have very strong marriages and have created good Jewish homes."

Needless to say, Kerry is not your average rebbetzen. While she partic-

ipates in the life of the synagogue, she does not in any way function as a surrogate rabbi. The hardest thing for her is the social demands. "I'm basically an introvert, and being married to Peter requires a lot of extroverted behavior. We're in the public eye a lot." However, Kerry is very sure of herself. She's not having an identity crisis. "I was in my forties when we got married. I knew who I was and what I was getting into." Peter agrees. "I don't think Kerry struggles with being a rabbi's wife; it's just that the time commitment is immense. We socialize every night, but we prefer being alone with one another. The challenge becomes to create your own sacred space in life. Sometimes you feel like you're drowning."

How do they create that space when they have so little time? "We try to make our rare time alone quality time. I'm rather independent, always was, but when I'm not with Kerry, I ache to be with her. Even if it's a matter of—it may sound silly—when I'm leaving the office late, I will call Kerry, and she'll walk to meet me on the way. Sometimes that's all we have—just those few minutes together."

For Peter and Kerry, the sacred is what they create every day, of their own volition. As Peter explains, "The Jewish wedding ceremony places the responsibility on the individual, who has to own his or her decision to be married to this other person. Each couple has the task of creating sacredness in their union. God does not give it to you. The congregation does not give it to you. Society does not give it to you. It's up to you."

GAIL SHEEHY AND CLAY FELKER

Breaking Through

Seventeen years is a long time in the life of a couple. Especially when that's the length of time that passes *before* they make a commitment. The couple in question are Clay Felker and Gail Sheehy.

He is the brilliant, cosmopolitan editor, who left his stamp on some of the most notable publications of this era—the founding editor of *New York* magazine, and the man who launched *Ms.*

She is the pulse taker of a generation who helped define the zeitgeist with her book *Passages;* who, in books and magazine articles, unmasked the complex forces that both energized and undermined relationships—most recently with *Hillary's Choice*, her best-selling examination of First Lady Hillary Rodham Clinton.

Gail always laughs when people express shock at the length of their courtship—"Seventeen years!"

But it isn't really so surprising, given where they started and what they overcame. When they met, he was a young editor and she was a young writer. She was a newly divorced single mother, and he was separated from his wife and married to his work. In the years to follow, Clay and Gail would relate on many levels—as editor and writer, as colleagues and collaborators, as friends and sounding boards. During some periods they would date. They lived together a couple of times. The attraction was undeniable, but their lifestyles were on entirely different tracks. Clay was "Mr. New York," a man about town, who reveled in the culture of the "city that never sleeps." Gail called him "a story

sponge." Gail was struggling to provide a stable home for her daughter and pursuing the more solitary life of the serious writer. Being a mom and living the night life didn't mix.

Besides, as Gail points out, they were very independent, modern people. "We really didn't have to get married. We both had very exciting lives. If we were together, getting along, great. If we weren't getting along, we could both do very nicely on our own. We weren't going to have a child together. I had my daughter. And Clay's child was whatever magazine he was working on."

The change began in 1976, although neither of them knew it at the time. Gail's daughter, Maura, was preparing to leave for college. Clay had just returned to New York after an experimental job switch to 20th Century Fox in California. This was during one of the couple's "on again" periods. Clay decided to take a year off to clear his head. He traveled to Asia with a friend, and later Gail met him, and they went to Thailand.

"We were staying at the Oriental Hotel, having breakfast on the terrace one morning," Clay recalls. "I was reading the *Bangkok Post*. Gail was sitting there, kind of depressed, because Maura was leaving for college. I started reading an article about these orphans who were in refugee camps on the Thai–Cambodian border. I showed the article to Gail, and I said, 'Maybe you'd like to adopt one of these kids.'"

It wasn't as if the idea had come out of the blue. Gail had talked about adopting before, and now with the empty nest looming, Clay thought it might be a good time.

Gail is the kind of person who springs into action when she puts her mind to something—even when it seems impossible. They were leaving the country in two days. How would they get permission to go to the refugee camp, find transportation to the border, dodge the fighting, see the children, and make a decision about adopting in two days? Somehow Gail managed to cut through the red tape and get permission to visit the camps. They hired a car and headed for the border. The first camp they visited had no orphans. They had been absorbed into extended families. But people told them about another camp where there were many orphans. Unfortunately, their time was up. It wasn't the end of the story, though. At the airport, Gail made a call to *The New York Times* and pitched a story idea about the Cambodian refugees America forgot. By the time Clay and Gail arrived in New York, she had an assignment to return a week later.

In the refugee camp, Gail interviewed twelve little girls through an interpreter. The last girl was

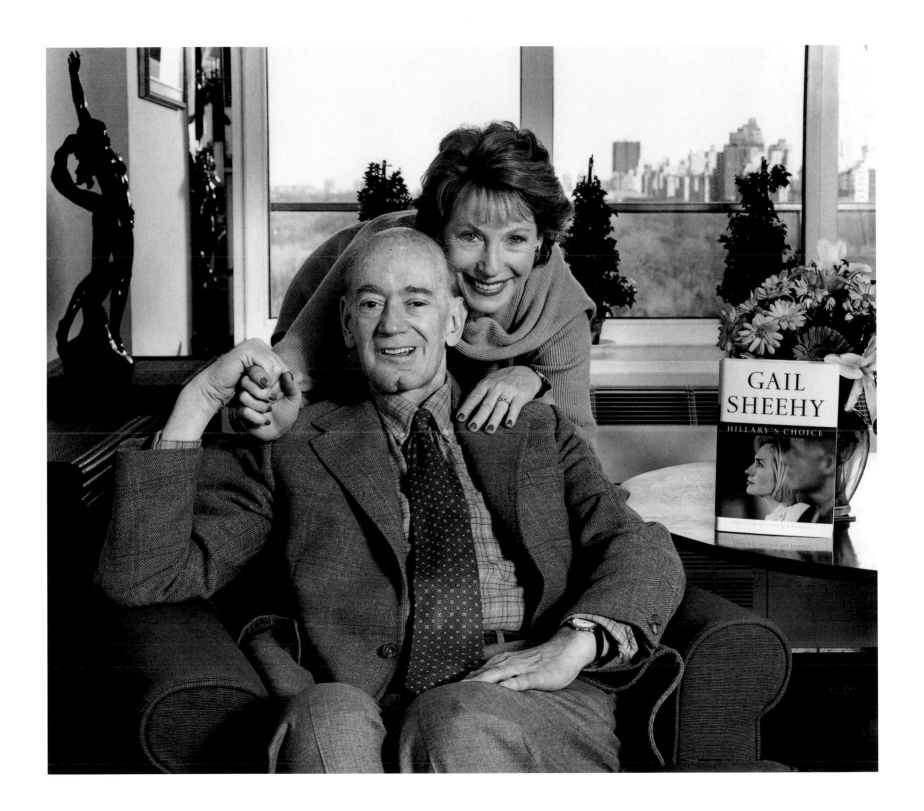

different than the others. "She was only eleven," Gail says, "but she had managed to resist the self-effacing identity of a refugee. She was very proud and strong. She spoke no English, and she'd only had two years of schooling in the camp, but she was obviously very bright. I fell in love with her—but I couldn't even get her name."

As Gail came out of the hut where she was interviewing, she was surrounded by a crowd of refugees, pulling at her and thrusting letters at her to take with her. Over the din, she shouted to the interpreter, "What's her name?"—meaning the little girl in the hut. All she got was "Mom! M-o-m."

When Gail returned to New York, she wrote a letter to "Mom" (she would later change the spelling to *Mohm*) in care of the refugee camp—not really expecting it to reach the girl. "And unbeknownst to me, she did receive it. She wrote a letter to me, and unbeknownst to her, I received it. So I started instituting proceedings to adopt her."

This would be an excruciating ordeal. Communications were nearly impossible, documentation was nonexistent, and the United States had placed heavy restrictions on refugee adoptions. Gail had to find an adoption agency in New York that would agree to sponsor the child if Gail could get permission to bring her in. Meanwhile, she began to write op ed pieces criticizing the refugee policy.

The months dragged on. The adoption agency went out of business. Friends active in refugee work told her that the Reagan administration was punishing her for the op ed pieces by not allowing Mohm to be released.

"I thought it was hopeless," Gail says, "and Maura and Clay were both starting to turn cold to the idea. It just wasn't happening." To add to her stress and frustration, her relationship with Clay was now "off again," and she missed her daughter. Things weren't working out at all.

One morning, Gail walked into her apartment after running, and there was a message on her answering machine: "Mohm arriving tomorrow night, JFK, 8 p.m."

The instant of Mohm's arrival is etched in Gail's memory—the small girl walking off the plane, clutching a little plastic bag and a little red plastic pocketbook that contained a map of the United States with a yellow dot on New York and, all the way down at the bottom, folded up, Gail's letter. "She didn't even know where she was going. She thought she'd landed on another planet because so many people had light hair and light skin. And when they opened their mouths and spoke, it didn't sound like anything she could recognize. But in the midst of all this, there was somebody she recog-

nized—me. So she said, 'Hi,' and I took her hand, and we walked out of the airport together, and started off on this great adventure."

The first two weeks were very difficult. Mohm was undergoing a phenomenal adjustment, and Gail didn't want visitors—even Clay, who was hammering on the door to meet her. Finally, after Mohm had been with her for several weeks, Gail invited Clay to dinner.

"Mohm cast her spell," Gail laughs, and Clay nods sheepishly. "She asked Clay if she could dance for him, and she put on a sarong and did a beautiful dance. Clay was utterly mesmerized. I mean, he was a goner. After that, he had to come and court her for the next six months, because she was very possessive of me."

Clay's face softens. "That's when the commitment happened."

"Yes," Gail says. "It was around this crazy adventure, this risk of taking a child from another culture, who had been through hell and back. But we believed in her, and we loved her, and that allowed us to be together."

"I wanted to be a father. I wanted to be home for her," Clay says. "It changed my life."

Today, Mohm is married and finishing her master's degree in psychology in Cambridge. Maura, a psychotherapist practicing in New York City, is expecting her first child. Gail is writing. Clay is teaching at the Felker Magazine Center, Graduate School of Journalism in Berkeley. They're all busy, their lives divided between the East Coast and the West Coast. But in the most important way of all they're together. They're a family.

BILL AND JUDITH MOYERS

An Act of Creation

"You walk into a strange room," Bill Moyers is saying. "It's not of your design, but you feel instantly at home. Somehow another person has arranged the order of things so that you fit. That was the experience of meeting Judith."

Bill Moyers's soft Texas drawl could be mistaken for shyness, but it is a blend of almost reverential fascination for life and an old-fashioned Southern courtesy that lives in his bones. Slight, youthful, and quietly intense, with the open face and easy manner of an interviewer, Bill seems to bask in the poetry of mundane life. During his twenty-five years in broadcasting, he has become one of our country's best loved and trusted journalists and thinkers. Before entering that field, he was deputy director of the Peace Corps in the Kennedy administration and served as special assistant to President Lyndon B. Johnson from 1963 to 1967, including two years as White House press secretary. Beside him through it all has been his partner, creative collaborator, and wife, Judith, president and executive producer of their production company, Public Affairs Television, and coexecutive editor of most of his projects. Married for over forty-five years, they have three grown children.

Silver-haired and vivacious, with her own faint Texas drawl, Judith appears to be the balancing center of Bill's life. Seated side by side in the comfortable living room of their apartment on Central

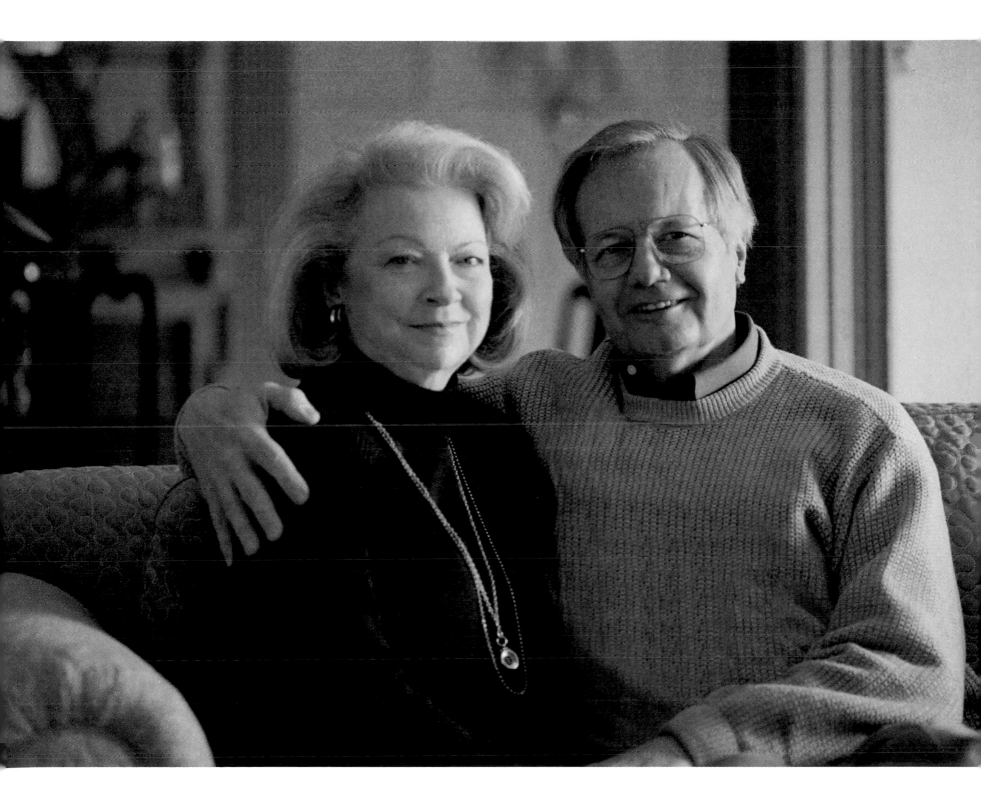

Park West, they turn toward each other like facing pages of a book. Judith looks up at Bill, both fig-uratively and literally, while he gazes across at her with frank admiration.

Certain couples look as if they belong together. There is a symmetry—they even resemble each other. This is true of Bill and Judith.

How did they know, so many years ago, in youth, that each was the one? How does anybody know?

"Was it heart palpitations?" Bill muses now. "Was it magnetic appeal? Was it just two like-minded people coming together like stars forming? I don't know." What he does know, and Judith agrees, is that it happened instantly, and, remarkably, the magnetism has survived the decades.

"Nobody believes the story of how we met, but it's absolutely true," Bill says. "It was on the first day of college. When we arrived at the University of Texas, everyone had to take a placement test to determine which English class you were going to be assigned. My friend Don Rives and I arrived late at this big amphitheater filled with three hundred students, and we got the last two seats in the final row. I sat down behind a young woman who had this gorgeous black hair that fell down across her shoulders. It was really beautiful. And I turned to Don and said, 'I'm gonna marry her.' "

"He didn't see my face," Judith teases, in the practiced manner of one who has recounted this tale many times. "This is a very suspicious story."

"But true," Bill insists. "Later the test results came in and we were both assigned to the same English class. As chance would have it, my seat was right behind hers again, although at that point, I wanted to see her face in front of that beautiful hair. When the class was over, I noticed she had left her books in the desk. And so I went up to Dr. Osborne, the English professor, and told her, and she said, 'Why don't you take them over to Bruce Hall, where she lives?' And so I did, and when she came down the stairs, that was that."

But how did they *know*? "I don't think there's anything rational about love," Bill replies. "When you really fall in love with someone there isn't any logical explanation. In my case I think there was a gravitational pull toward Judith because we really have very common values. We both grew up in the Baptist Church. We both were interested in English as literature and language. We both had a sense of vocation in the world."

Bill speculates that it is this sense of common values and, indeed, *mission* that may be the missing

element in today's failed unions, and Judith agrees. "Self-fulfillment was not the craze then that it is now," she explains, "in the sense of everything being for one's own personal gratification. We shared a strong commitment to the world, a sense that our marriage was important, not only to us, but to our work, our children, and to those around us."

Over the years, through many shifts, Bill and Judith learned to view their marriage as a dynamic force, ever expanding and changing. Bill describes it this way: "You begin committed to the relationship with the other person. You want to keep the commitment because you want to remain married. Then children arrive and your commitment enfolds them into it. You're not willing it to change, you're not shifting the gears; they shift automatically. It shifts with children. You're in a community and your neighbors become part of it, and your colleagues become part of it, and pretty soon what began as an individual and then mutual world becomes a collective world. And you are engaged in it. Before long you discover that a small but signifying constellation surrounds you. It's really impossible for me to imagine not being in the world that Judith and I have created over these years, which includes our children, and their spouses, and our grandchildren, and our nieces and nephews, and the memories that we have in common. It would be like walking naked into the world without these relationships.

"That's why death is so hard on the survivor after a long marriage. It isn't just the loss of a person, it's the collapse of a world that has accumulated. It's the same way that the furniture in this room has accumulated over our lifetime, and we're attached to it for different reasons." He looks around their spacious living room. "For example, we bought those two paintings over there from John St. John when we were young and vacationing in Puerto Rico. If you took those paintings down, it would show on the wall, and it would also show on our interior walls. They're our history. We create a collective world through the ongoing, daily, sometimes unthinking willfulness that welcomes other people and ideas."

"And after a certain point, you just don't want to sacrifice the history," Judith adds. "We wouldn't want to start over. That is not to minimize the challenges we've had to work through during our marriage. The White House years were the hardest. Our third child was ill and hospitalized. That was extremely difficult. I've often heard people say that times like that draw you together, but I don't think that's true at all. I think they release a stress level that's exceptionally high. How did we get through

it? That's the commitment—the willingness to compromise, to change, to work hard, to never say this could break up our marriage."

Bill is candid in his admission of failures—and points to a particular period when he was consumed by work, when he was distracted and insensitive. "I went through a period, sad to say, when I took for granted there was no price Judith wouldn't pay because of her commitment. And I don't know how it is with women, but when a man starts reaching middle age, he begins imagining the road not taken, the possibility of another life. You don't do this willfully. But a lot of people yield to that, and it can lead to the breakup of your marriage."

Although the Moyerses held steady, that is not to say that the crises of commitment do not take a toll. "There's always scar tissue," Bill notes. "That's part of the history as well."

Judith adds, "I think part of being committed is knowing you're not stuck in this. You have to keep working. I knew somebody who got a divorce after they'd been married for fifty years, and I remember thinking at the time, how crazy can you be?"

Bill says, "Yet commitment isn't a value exclusive of all else. I think some commitment can be suicidal. I've seen marriages that are destructive to people. When commitment is mere duty, and there's no leavening of joy—and if you can spare innocent people like children from being hurt—there's an argument to be made for leaving."

Every couple has its strategies for staying strong when emotions threaten to blow in the door like a hot wind. "To me, the key is never to walk out, except maybe into the next room," Bill says. "I'm an intuitive person, all of us are, but there are some impulses that have to be addressed. At times, in anger, the thought of bolting flew by, but I never allowed it to nest, because in the end I couldn't imagine my life without Judith. I may have said that I wanted out, but I never went past the front door. That far, but no farther."

Bill and Judith possess a serenity born of the confidence of their continuation. "There's a kind of craziness now to modern life," Bill acknowledges. "People are not engaged with each other. It seems to me commitment is a very powerful antidote to the toxic self-absorption so rampant in our society today. The person you love frames your life."

REYNOLD LEVY AND
ELIZABETH COOKE

Finding the Glue

Aᴛᴛᴇʀ ᴇɪɢʜᴛᴇᴇɴ ʏᴇᴀʀꜱ of marriage, Reynold Levy and Elizabeth Cooke can find plenty of humor in their family differences. "Reynold comes from a small, emotional, intense Jewish family," Elizabeth explains. "I'm one of five children in a gregarious but minimally emotional Catholic family, where feelings are never on the surface."

"Let me give you an example," Reynold offers. "This happened when Liz and I were dating. We visited her parents' house, and as we arrived, her mother had just returned from the grocery store. There had been an accident. Liz's mom was okay, but the car was seriously damaged. I mean, it was in very bad shape. So, we pull up in the driveway and walk into the house, and Liz starts chatting casually with her mother. 'How are you? Fine. That's good. Let's put the ice cream in the freezer. Leave the meat out, I'm doing the meat first.' Then her father, who's a physician, walks in the door. 'Betty, how are you? How was your day? What happened to the car? Did you call the insurance company? Yes. Are you okay? Yes. What's for dinner? Roast beef. I'll be down in fifteen minutes.' And then we have dinner, and it's entirely civil. After dinner, Liz and I leave to go to a movie, and when we're outside, I ask, 'So when are they going to talk about the accident? When do they have their fight?' Liz says, 'Fight? What fight?'"

Reynold is laughing now, relishing the memory. "In *my* family, my father would have already been

going on before he walked in the door: 'We didn't even need groceries. Why'd you go out shopping? Besides, you could have ordered the groceries. Had them delivered. Why did you take that route? That's a terrible intersection. You should have gone the other way . . .' and on and on."

Early in their marriage, these radical differences in style led to arguments and judgments. When Reynold's son from his first marriage fell in the school yard and cut his head, differences emerged.

"Reynold walked in and his face was ashen; he was horrified," Elizabeth recalls. "He started going on about how Justin fell and he was bleeding, and there was so much blood. And I'm trying to get to the bottom line. My father's a physician, my mother's a nurse, so I'm automatically assessing the damage. Finally I get it, and I'm relieved. 'Oh,' I say, 'he cracked his head open. Did he need a stitch?'

"Reynold was furious. 'How can you can be so callous? How can you be so unfeeling about it?' And I said, 'Hey, I'm one of five kids and we all cracked our heads.' He stared at me as if I were mad."

These differences took awhile to sort themselves out, but they weren't so significant anyway, because the glue that held them together was much stronger.

The glue. It's an idea Elizabeth comes back to again and again. "People can be different," she says, "but I'm always watching, wondering, what's the glue?"

For Reynold and Elizabeth it lies somewhere between attraction and intention. They are both fully engaged in the world—Reynold literally. As director of the International Rescue Committee, his attention is turned every day to some of the most blighted areas of the globe, and he frequently travels to places where war, famine, or natural disaster have left thousands upon thousands of people without homes or sustenance.

"We're different in many ways," Reynold observes, "but we have a common view of what we should do with our lives, what's important. We've never been particularly interested in social climbing, and we haven't exactly chosen paths that generate wealth. We're very oriented toward community and toward the poor, and we spend a lot of our time engaged that way. Liz is always involved in community-based activities, both professionally and personally."

Reynold and Elizabeth met on the gritty front lines of political action—not marching in the streets, but trudging through the mountains of paper and policy that went into securing a piece of the state budget. In the 1970s, New York City was in a financial crisis, and this posed a direct threat to the social service agencies. "We were worried that Mayor Beame and the governor would define

23

essential services as only fire, police, and sanitation," Reynold explains. "This would have a terrible effect on poor people. But the budget crunch was real, and I determined quickly that just saying no to the budget wasn't good enough. We had to come up with a counter-budget that balanced everyone's needs. So we formed a task force and did real revenue estimates and real expense reductions that were alternatives to what the governor was presenting. It was a solid document. Then they said, 'Go present it in Albany,' and I said, 'Which way is Albany?'"

That's where Elizabeth came in. She had experience lobbying in the state capitol, and someone suggested that Reynold solicit her help.

"The first time I called her," Reynold says with a teasing smile, "I asked, 'So what do people call you? Beth? Or Betsy? Liz? Or Lizzie?' And she replied, in a very dignified manner, 'They call me Elizabeth, thank you.' Without missing a beat, I said, 'Okay, Lizzie, here's what we need.'"

"This delights him," Elizabeth says. "Since that day he has never once called me Elizabeth. I'm Liz or Lizzie.

"From the very start," remembers Elizabeth, "there were a lot of things to talk about. A lot of energy and physical attraction. I don't know how to explain what it was. Why is it that you can sit and talk to one person for hours and hours? I don't know how to unravel that. But it was there."

What keeps their relationship exciting is that they are both enormously curious. "Reynold is much more focused on reading and intellectual exploration," Elizabeth observes. "And I am willing to risk more time meeting people. But each of us brings what we've discovered back to the relationship."

They both feel that their relationship has been strengthened by the bond each has formed with the other's child from a previous marriage. Reynold is very close to Elizabeth's daughter, Emily, and Elizabeth is close to Reynold's son, Justin. "One incident stands out for me," Reynold says. "I was in the Congo, and Justin had a musical opportunity in France. He was busy with many other things at the time, and getting organized was a challenge. Here I was, ten thousand miles away, and I was really concerned. What a relief that I could turn to Liz and ask her to help. I can't tell you what that meant to me."

"Justin needed some assistance," Elizabeth laughs. "There were so many details. Including finally driving him to the airport and asking him for the twentieth time if he had his passport. Just like a mom."

"*That's* commitment," Reynold says, applauding.

BARBARA SMITH AND DAN GASBY

A Chance Worth Taking

I︎ᴛ'ꜱ ʜᴀʀᴅ ɴᴏᴛ to be dazzled by the light that surrounds Barbara Smith, and Dan Gasby was no exception. The moment he first saw her, on Valentine's Day, 1987, working the room in her restaurant, resplendent in a red dress, he thought, "Wow!"

Dan, a TV producer, is a strong, outspoken guy, and he knows how to judge a person. As he puts it, "I've sat across from every kind of knucklehead, egomaniac and megalomaniac. I don't get fooled by good looks and a nice smile. This light inside of her was just glowing, and it was pure. There was no meanness."

Dan was married at the time, so he wasn't thinking about Barbara in a romantic way. But sometimes he'd bring clients to her restaurant, and as he got to know her, he knew he liked her. He felt good around her. In the coming years, they developed a friendly relationship. During that time, Barbara got married. Sometimes they'd talk about going out as couples, but it never happened.

More than five years passed. Both were busy, and they didn't see each other as often. Dan was now divorced and juggling single parenthood with frequent trips to the coast. Barbara was divorced too, and her restaurant business was taking off.

One day, Dan was sitting in a bistro restaurant in New York, feeling low. A program he had produced with Natalie Cole had been canceled, and it was a great disappointment. Through the restaurant window, he saw a sight for sore eyes.

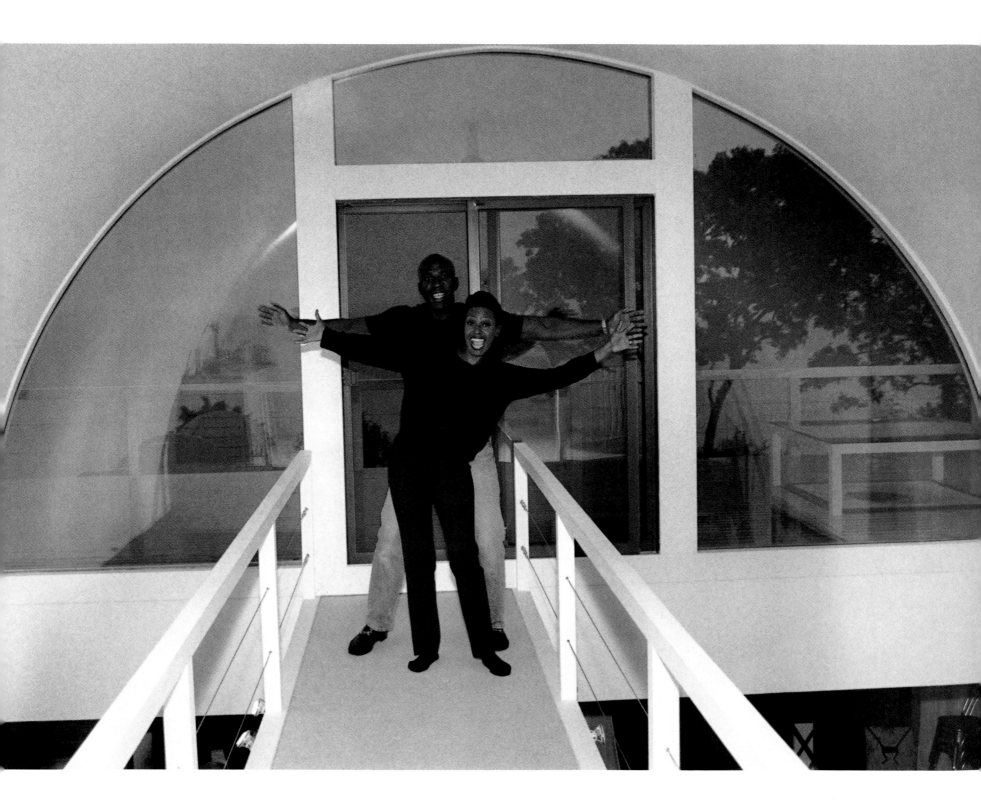

"There was Barbara." His eyes dance at the memory. "She was in a Jeep with her girlfriend, and she jumped out. She was wearing white pants, a navy blue blazer, and a naval officer's hat. And she looked gorgeous. I said, 'Can I have a hug?' She gave me a hug, and I asked for another hug and she gave me another hug. Then she pushed me back and looked me square in the eye, and said—"

"I said," Barbara interrupts with a coy smile, "'Your life would be a lot better if you made a phone call.'"

"So I did," Dan says. "We made a date, went to dinner, and then I walked her to Seventh Avenue and 51st Street, and I looked at her, she looked at me, and she gave me a kiss on the lips. A nice little kiss on the lips. I walked all the way back to Rockefeller Center about three feet off the ground. It was like electricity. It was like Con Edison went through me. And we've been together ever since."

It's a very romantic story, and these are very romantic people. They sizzle. But there's a serious side. In spite of their attraction, they had each been bruised by a failed marriage. Dan had a young daughter to think of. However, they were both blessed with optimistic spirits. Dan had a very practical point of view on success and failure: "I understood one thing," he says. "If a great person meets twelve terrible people, that doesn't make the great person any less great. Conversely, if someone terrible meets twelve great people, it doesn't make them any less terrible. I knew that I was a decent guy, and I knew I had something to offer, and I was hoping that I'd find somebody that would allow me to be me and allow me to love them. And I was fortunate enough to find that person in Barbara."

The years since their marriage have been full. Today, as they look out on the water through the glass walls of their Sag Harbor, Long Island, home, they can feel proud of their joint accomplishments. Barbara's nationally syndicated TV show, *B. Smith with Style*, which Dan produces, is a hit. They've recently launched a magazine of the same name under the auspices of American Express Publishing.

"We're about possibilities," Barbara says. "The message is, it's not where you're from, it's where you're going." She winks flirtatiously. "And it's okay to be fifty and feel sexy, and to want romance in your life."

Barbara and Dan are very conscious of being role models—of breaking through the stereotypes about black men and women. "I watch the way she touches people," Dan says admiringly of his wife. "I watch the way young women who came out of the projects, or were the first in their families to go to college, look up to her. She has built a very special connection."

But the influence extends even further. "I also see how the media portrays black couples," he says. "Or the lack of black couples. Or how black men are perceived in their relationships with black women. And I realize it's my responsibility as a guy, a black man with a daughter, to be supportive of her and to help her achieve something good for herself. And in a larger sense, to show her and others that two people, a couple working together, can accomplish a lot."

Dan is a very aggressive, self-confident guy, but he tries hard to resist the macho attitudes that he believes are so destructive to men—and, in particular, to black men. "So many guys are locked into that ego trip of being the main breadwinner, or the boss," he says. "Well, people call me 'Mr. B. Smith,' and I even use that title myself. It's okay."

Not that it's all wine and roses. Barbara and Dan don't want to leave the impression that they live some kind of fantasy life. To the contrary, they work extremely hard. They also have their share of disagreements. It's no secret that these two have very different ways of relating—Dan is a rumbling, dominating presence in a room. He can be confrontational. Barbara is soft and soothing. She pulls people into her circle with warmth and encouragement.

As Barbara says, bluntly and accurately, "Dan is very much in your face. He's got a *big* personality. And especially when we're dealing with employees. I am a little gentler. I tend to massage more." She hastens to say that neither style is better or worse. "We try to respect each other in that way."

She does acknowledge that it gets a bit touchy sometimes with Dan's daughter. "I'm not her mother, I'm her friend and her stepmother," she says. "I relate to her in a more easygoing manner. Dan is"—she wags a finger—"'*Tch, tch, tch, tch*'—a bit more strict. And sometimes she'll say, 'I like it when Barbara wakes me up, because she never screams.' Seriously, though, I like the fact that she sees how much we care, about each other and about her. One of the things I tell her all the time, even when I'm annoyed with Dan, is, 'If I weren't married to your dad, I'd marry him again.' So she sees we're a team. We're in it for the long haul."

CLIVE AND BONNIE CHAJET

Romance in Laughter

ADVERTISING AND MARKETING legend Clive Chajet knows how to break a complex question down to its most rudimentary elements. So when he is asked what has made his thirty-four-year marriage to Bonnie work so well, he has a simple answer: "We say please and thank you."

Clearly, he's not talking about mere propriety, though that wouldn't be surprising coming from a proper Englishman. "When you use please and thank you, it's a signal that you don't take anything for granted," Clive explains. "You are recognizing the specialness of any act."

His wife Bonnie chortles wickedly. One suspects that it would be impossible to take this woman for granted in any situation.

Clive and Bonnie, in matching white dress shirts and chinos, are like a finely tuned performance team, whose mutual affection and sense of fun are always bubbling to the surface. Every story of their relationship is capped with a humorous and often self-deprecating punch line—starting with the tale of one of their first dates, a bike ride in Central Park.

Clive begins the story. "We were riding around Central Park on the weekend, and we sat down on a bench to cool off. Then, well, Bonnie did something that, had somebody else overheard, I'm sure they would have been offended."

"I burped," Bonnie elaborates.

Clive was appalled. "I said, 'Bonnie, don't do that. Someone will hear and be insulted.' To which she replied, 'When they pay my bills, I'll worry about what they think about me.' And that convinced me that we were two peas from one pod."

The incident was also predictive of the way Clive and Bonnie would continue to relate to each other. "There are people who constantly have to prove themselves to their mates," Clive says. "I don't think that we ever felt that we had to prove ourselves or try to impress each other."

At the time of their marriage, they didn't exactly have the funds for making impressions. Clive was earning $18,000 a year as a designer for a packaging manufacturing company. Bonnie, a secretary at J. Walter Thompson, made $3,000. "We started with zip," Clive says. "I borrowed money from the Chase Manhattan Bank to pay for our honeymoon." Three years later, with the birth of their first daughter, Bonnie quit work. A second daughter followed, and Clive moved on to start his own packaging design firm with advertising entrepreneur George Lois.

When their two daughters—now thirty-one and twenty-nine—were in school, Bonnie started thinking about work. "I knew I'd be bored if I just stayed home," she says. "What was there to do? But in those days, many of my friends didn't work, even after their kids were in school." Her gregarious personality and a lifetime spent in Manhattan led her into the real estate business. It was also a great choice of profession for a mother of two, allowing her as much flexibility as she needed.

Clive was enthusiastic about Bonnie's decision, and he supported her career all the way. "That was unusual, too," Bonnie says wryly. "I had a group of friends at the time whose husbands weren't at all supportive when their wives talked about going back to work. They seemed threatened by it. They'd say, 'How will I get my fresh string beans and broccoli at night if you're working?' But Clive recognized that I needed to do more with my life than prepare his vegetables."

As they reflect upon the high rate of divorce in modern society, Clive and

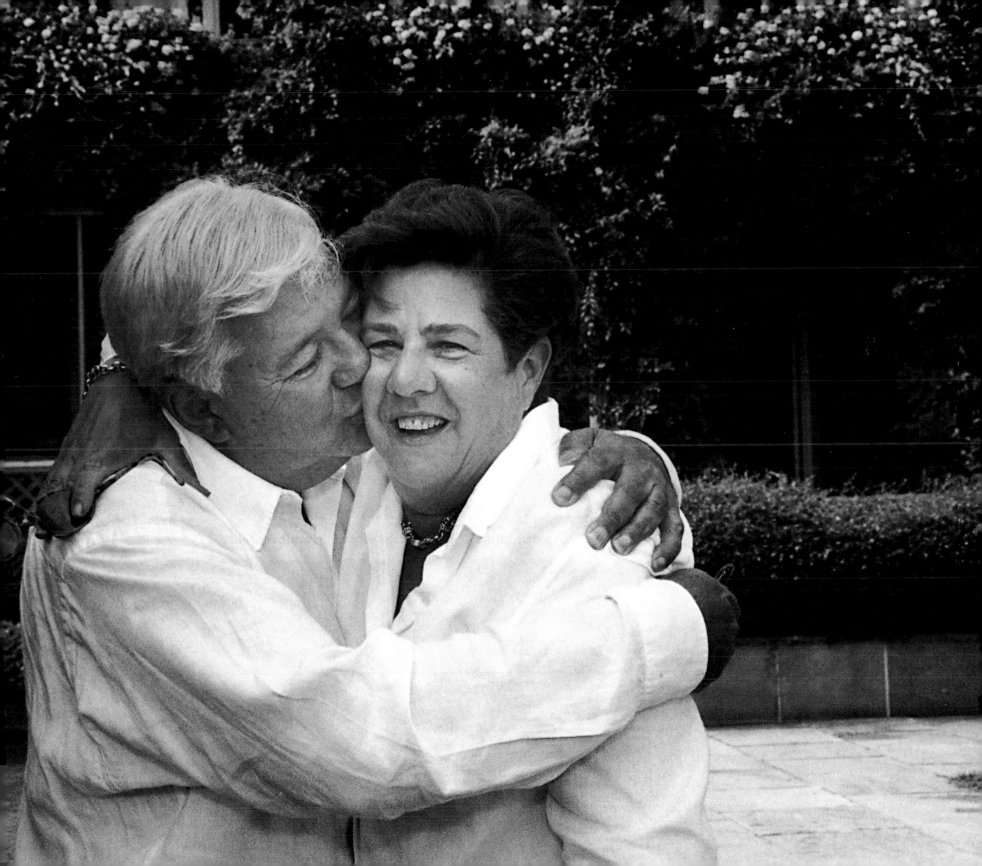

Bonnie admit to being somewhat baffled. Even though Clive's professional success has largely been a result of his ability to define public moods and motivations, he acknowledges that the marriage statistics are an enigma. "I will tell you this," he says. "I'm from a very traditional, Orthodox Jewish background. When I was growing up, I didn't know anyone who was divorced. None of my parents' friends were divorced. It didn't even get raised. Today, divorce is a very simple option, but here's the puzzle. People want to be married. They don't go into it thinking they're going to get divorced in two years. So why is the incidence of failure so high? It may very well be that the key is religion. Whether you are Christian, Muslim, or Jewish, your religion is going to play a role in shaping your marriage. In the Jewish religion, divorce is an allowable event, but there has always been a stigma attached to it. Not a religious stigma, but a social stigma. In the Catholic Church, divorce is essentially forbidden. Again, there is a stigma. If you are part of a community that strongly discourages divorce, you will be less likely to go against the community. Instead of divorcing, you will tend to look at other ways of solving your problems."

Clive and Bonnie have achieved an enviable place of harmony and contentment. They are fulfilled in their work, proud of their daughters, and enjoying each new stage of their life together. As they relax in the comfortable sun room of their Bridgehampton home, overlooking the verdant expanse of lawn, they acknowledge that they are very fortunate—that life has given them much.

"Maybe it's easier to have a good marriage when you have money," Clive says. "But I will also say that the luckiest people I know are the people who have good marriages regardless of economic status. A good marriage is such a blessing, such a source of happiness and satisfaction. It dwarfs the value of money. Maybe it's easy to say because obviously we're well off. Would we have as good a marriage if we had been poor?"

"I think that if you're poor and you have to struggle for things, that does create problems," Bonnie says. "Economic pressures can put a strain on a marriage."

Clive shrugs. "But if it was just money, why are there so many divorces among the rich? I don't think you can reduce it to money. Besides, we were happy poor, too. It must be love."

STEVE AND COKIE ROBERTS

An Act of Faith

WHEN STEVE ROBERTS met Cokie Boggs in 1962, there was little reason to expect that they would spend a life together, have children, and lay claim to a common tradition. Not that the attraction wasn't there. It was, almost from the start. Even as the awkward flirtation turned into dates, they didn't allow themselves to think it was serious–just a "spring romance," they said. Steve was Jewish and Cokie Roman Catholic, and while mixed marriages weren't unheard of in the early 1960s, they weren't on the agenda of serious young people who were closely bound to family and tradition.

There weren't many choices. "We couldn't just ignore who we were," Steve says. "We both cared so much about our families, and conversion was out of the question. We had been taught that mixed marriages couldn't work—how would we raise our children? It would have been easier if we didn't care so much, or if one of us hadn't cared so much." So they agonized, and the months turned to years—four of them, to be exact. They learned during this period that the values they shared were strong enough to overcome the differences in their traditions. And they set out to invent a new tra–dition that embraced both.

Today, thirty-four years later, in their Bethesda, Maryland, home—the same charming colonial where Cokie grew up—they seem a comfortable and familiar fit, most of the rough edges smoothed

by the stable life they've built together. They can say now, and mean it, that being of different religious traditions has been a source of bonding more than a division.

"The fact that we care about tradition is a reflection of the fact that we care about family," says Cokie. "We care about the celebration of home and of ritual in the home. All of this makes a marriage stronger."

Steve agrees. "I think the factor of mixed marriage actually helped us. We learned very young to respect each other's traditions. We learned very young to make room for each other's tastes. And I think it taught us that marriage is a series of compromises. In the end, it was actually a great benefit—far more of a benefit than a problem."

Clearly the key is a willingness to make those compromises, to achieve a partnership. But what does that mean? Cokie and Steve have given that a lot of thought lately, in the course of writing a book together. *From This Day Forward*, published by William Morrow in early 2000, is their honest look at the makings of a marriage. Both conversational and probing, the book is a fine legacy for their now married children.

"Frankly," says Steve, "commitment is a difficult concept for people these days. The message of modern psychology and therapy is often self-actualization. Worry about yourself. And look, I don't disagree with that. I do think that people have a right to focus on their own aspirations and their own needs. But you have to understand that marriage is a partnership. If you get up every day thinking about yourself—thinking, 'How am I going to grow today? How are my needs going to be met today?'—that's a formula for marital disaster. You have to balance the drive and desire for individualism with a sense of partnership, a sense of accommodation. There were many years when Cokie accommodated her career to mine. And today there are ways in which I accommodate mine to hers. Over the last six weeks she's been under a lot of pressure at work. We write a joint column. So I said, 'Okay, for this period I'll write it every week that you can't.' It's a way of rearranging the work so that we could help each other out. Small things, to be sure, but important.

"I've written a lot about marriage and divorce," he continues. "I remember talking about it to a counselor once who said, 'If you were to get up every day and ask the question, 'Why should I stay in this marriage today?' there are going to be days when you don't have a good answer.'"

"A lot of them!" Cokie laughs.

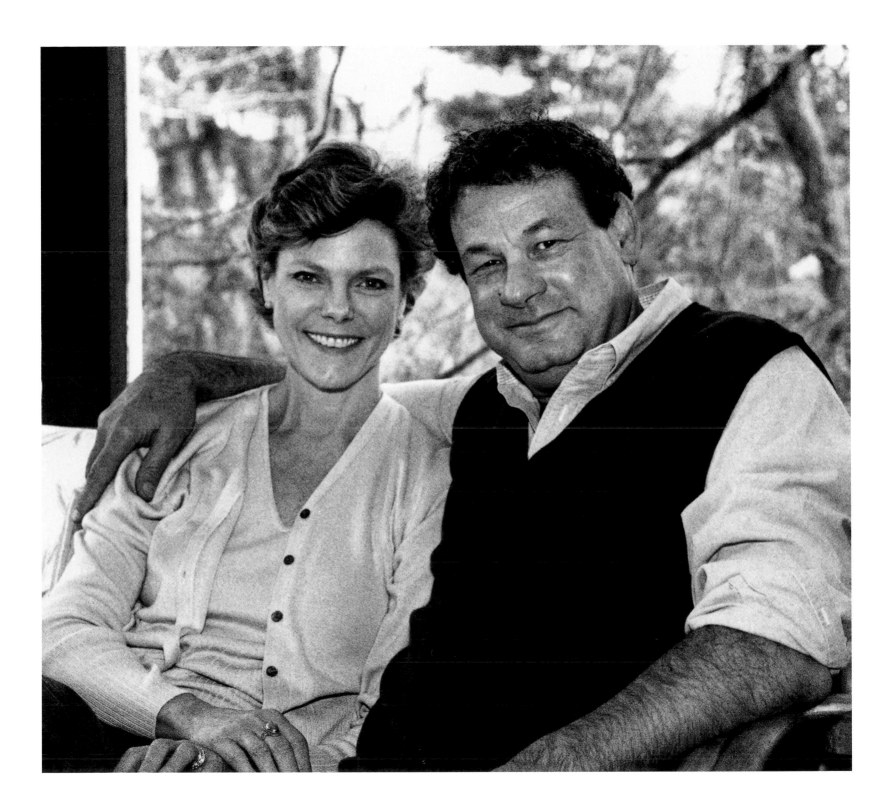

"Therefore," Steve concludes, "you have to have an underlying commitment. You have to know there's something on the other side—whether it's today or next month—and you're going to hang in there and make it work."

When talking about the ability to compromise, one cannot discount the importance of temperament, and it's worth noting that the Roberts are not high-strung people. Professionally driven, to be sure. Busy balancing their public and private lives, yes. But, as Cokie puts it, "We're both essentially sunny personalities—optimists. There are times when I get a little more depressed than Steven does, and there are times when he gets a little more angry than I do. But we're basically upbeat."

Steve grins. "Sometimes you just have to laugh. Fortunately, we do. A lot."

DR. MITCHELL AND
SARAH ROSENTHAL

⧉

A Safe Place

Mitch and sarah rosenthal freely acknowledge that they entered each other's lives broken. Mitch, a psychiatrist and the longtime president of Phoenix House, the renowned drug rehabilitation center in New York City, had suffered two failed marriages. Sarah, a social worker, had never been married, but she was struggling to extricate herself from what she knew was a very unhealthy relationship.

As is often the case, Sarah's relationship followed a pattern set early in life. "My father was moody and dark," she says frankly. "It's what I knew." Mitch was different—predictable, compassionate, and even-tempered. What started as a professional relationship grew over time into a deep friendship.

"Mitch helped me to separate from this guy, over a long period of time. He was patient and understanding. I'd leave, go back, leave, go back. He stood by me."

Mitch was being a friend. He genuinely wanted to help Sarah, and that came first. "But," he adds, "this was not at all a cerebral exercise on my part. I was wild about her, and I felt a deep connection with her. But I held back because I understood her struggle. I'd been there myself, and I knew what she was going through. Privately, I was completely taken with the free, loving spirit and physicality of Sarah."

As Sarah extricated herself from her destructive relationship, she found her feelings for Mitch growing. When he finally asked her out for a date, she felt both happy and apprehensive. "I worried

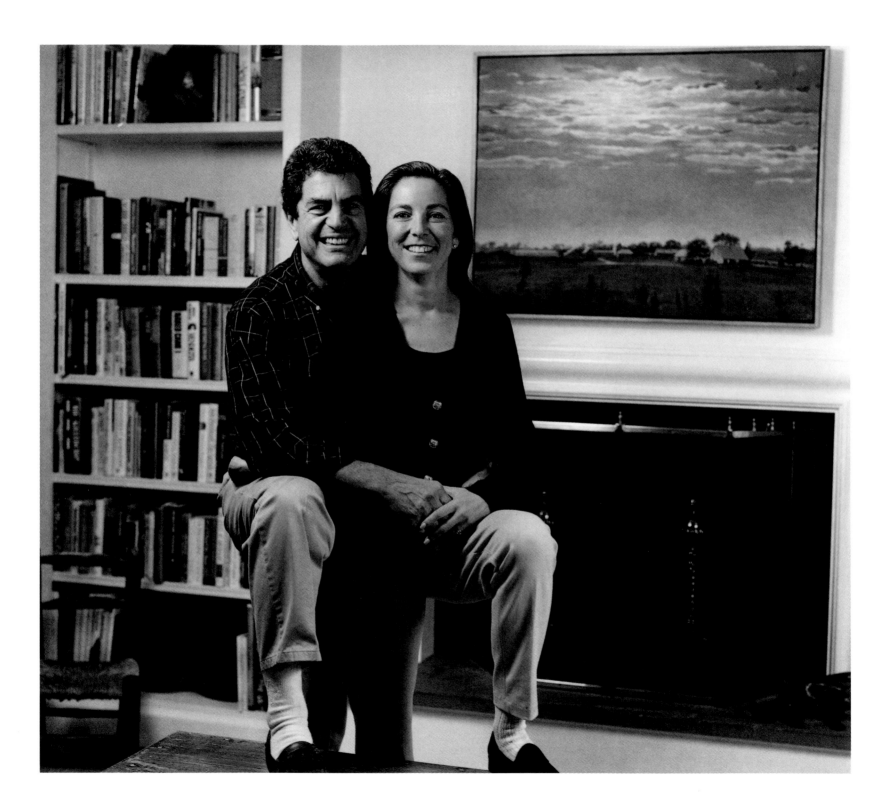

that I wasn't ready, that it wouldn't work," she says. "But being around Mitch was so easy. Little things—playful, fun things. That element had been missing for me."

Any fears she might have had disappeared on their first date. "Mitch showed up at the restaurant on his bicycle," she recalls gleefully. "Now this was a very elegant restaurant, so right away it was something different. Then, after we had a wonderful dinner, I got on the handlebars of his bicycle and he pedaled me home, down Second Avenue. I was thinking, 'Yes, I like this.'"

The next eight months were idyllic, what Sarah describes as "that wonderful stage of early love. We were crazy about each other." It felt natural for them to live together, and their blossoming attachment led to talk of marriage. That's when Mitch froze. "I'd had two bad marriages and been single for twelve years," Mitch says. "I suddenly started to feel trapped and uncomfortable with the idea of actually getting married again."

Mitch freely admits to a bout of severe cowardice. He's not proud of the fact that at the time he was hoping to just live with Sarah—hoping she wouldn't bring up marriage. When she did, he pulled back. It was a terrible time for them.

"I never would have agreed to our living together if I didn't think it would lead to marriage," Sarah says, remembering the pain of that period. "I thought Mitch felt the same. He'd always told me he wanted to be married again. I don't think he was lying to me. He believed it. But when it got too real, he couldn't face it."

Sarah moved out. She moved back in. She moved out. Mitch pulled away. He moved closer. He pulled away. They performed an elaborate dance of uncertainty and fear.

"It was torture," Sarah says soberly. "And it was destroying me. I finally told Mitch I couldn't do this anymore. I meant it, and he saw that I meant it. That's when he made the decision—not because he wanted to be married, but because he didn't want to lose me."

"And then," says Mitch, his face brightening, "the most miraculous thing happened. The rhythm of our lives made everything possible. My fears left me. Living with Sarah, being married to Sarah, was easy and wonderful."

That was ten years ago. Today, the turmoil is a distant memory, and Mitch and Sarah wonder at how hard it was to choose something so easy.

But this is, after all, Mitch's third marriage. Does he worry about his track record—fear he won't

be able to sustain this marriage either? He doesn't worry about it anymore. Being with Sarah has forced him to confront the way he was in his former marriages—his impatience, his demands, his expectations. "I'm lucky to have another chance," he says, "because I think I'm a much better partner in this marriage. I'm more mature, and I understand more about what I did to contribute to the failures of my first two marriages."

The light at the end of the Rosenthals' separate tunnels has a redemptive glow. There are so many people who have given up hope of finding that level of commitment. Still others stay in destructive relationships because it's all they know. Maybe for them, there is another way too.

GERALDINE FERRARO AND JOHN ZACCARO

A Tradition of Strength

THE BIGGEST SURPRISE about John Zaccaro and Geraldine Ferraro is how playful they are together. The public is accustomed to seeing their faces—she intense, he grim—staring out from newspapers and TV screens. In the fifteen years since Gerry was chosen to be the first woman vice presidential candidate, the couple has endured an ongoing assault on every aspect of their business, financial, and personal lives. Having faced circumstances that would test the hardiest marriages, John and Gerry might be expected to show some of the weariness that accrues with age and hard knocks. Instead, they banter, tease, and touch in the manner of fresh love, plainly feeling lucky to be together. Gerry says admiringly, "John is the best. A wonderful father, a wonderful husband. My single women friends are always saying, 'Find me someone just like John.' We were best friends when we got married," she adds, noting that their courtship lasted five years. "And we're still best friends. We don't run out of things to say to one another."

The constant theme in their lives has been the strength of family—not in the limiting sense of shutting out the world, but in the expansive sense of building a solid foundation from which to branch out. They have managed the difficult task of allowing each other to be individuals within the couple. "I never tell her what to do," John says respectfully. "I'm behind her one hundred percent, and I always have been, through all of her campaigns."

Gerry mirrors this attitude. "What keeps John happy is real estate. I wouldn't dream of interfering with his choice of career."

But what about when a partner's career choice threatens the family? The 1984 vice presidential campaign, which should have been a glorious moment for the family, turned into a nightmare. The press was relentless about digging into every real estate transaction and financial deal John and his father had ever made. The pain of that period is imbedded in the fabric of their lives. Gerry still chokes up when she recalls the night her strong, steady husband broke down and cried from the frustration of it. "The press was demanding detailed financial disclosures," she recalls, "and John and I decided to put everything on the table, to go way beyond any legal requirements. There wasn't a single detail of our financial life, right down to the last gift, that we would withhold. I didn't really understand John's business, so I had to cram a lot of information into my head in a few days, preparing for questions I'd get asked when I appeared Sunday on *This Week with David Brinkley*. Late Saturday night, I found John tearing through piles of old records, trying to find an item of income from years earlier. He was frantic. He looked at me with total despair and threw up his hands. Then he started crying. I ran and put my arms around him, and I started crying too. At one point I looked up and saw our son, John Jr., standing in the doorway, watching his parents crumble. It broke my heart. In the end, the campaign devastated me. Not because we lost, but because of what the campaign did to my mother, my husband, my children. They were so hurt. It wasn't fair."

The crisis did not, as some people speculated, place the marriage in jeopardy. "The rumors that we were going to split up were so ridiculous," Gerry says. "Why did people say that? Obviously, they didn't know us. They were judging us by the superficial. Or they were judging us by their own standards, thinking, 'Oh, my God, my marriage would never survive this.' But they had no concept of where we were in terms of our religion, or our commitment to each other. So those opinions never had an impact. We didn't care what other people said, because they didn't know us."

"We have always been able to talk things through and not let them fester," John says. "Even during the worst times, we always said when you put your head on the pillow, it's done. Tomorrow is a new day."

There is an assumption in the populace that every marriage has a water line, a drowning point, where the oxygen disappears. When we observe couples struggling with public crises, we ask, "Will

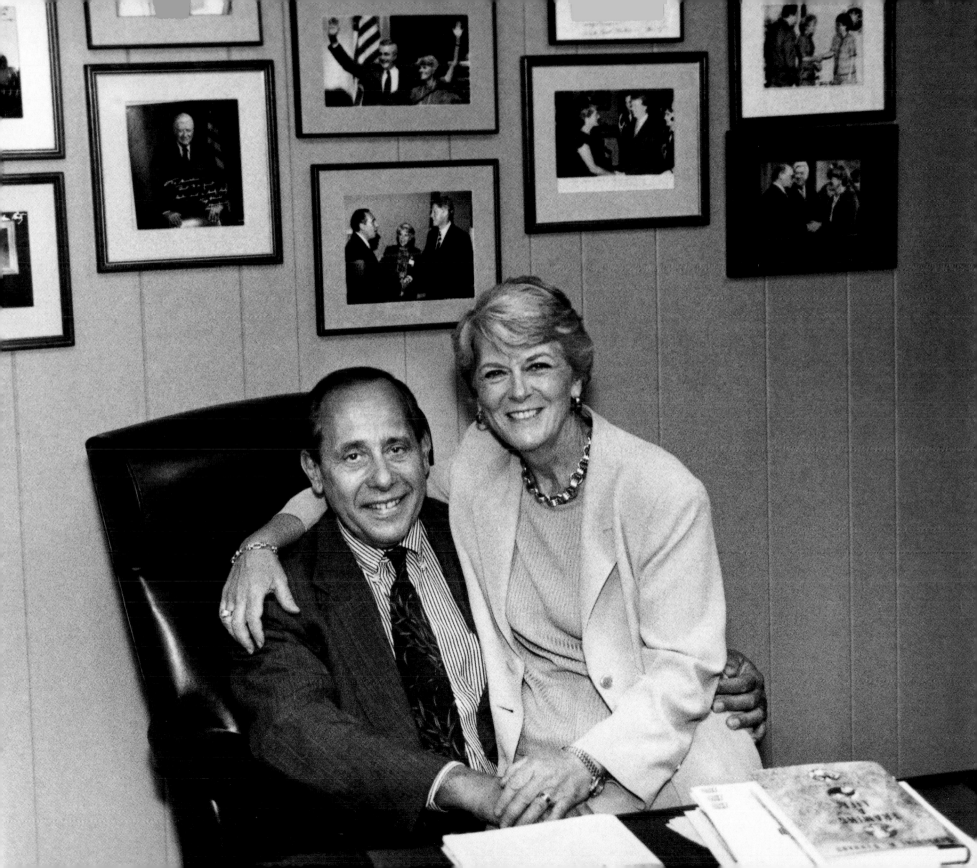

this do them in? Or *this*?" When John and Gerry try to articulate the depth of their commitment, they are, in effect, saying that there is no drowning point for them. The notion of separation is foreign to their identity as a family. Their resilience is one part "you and me against the world" and one part the instinct of their Italian heritage. In the first eight years of her life, before her father was snatched by an early death, Gerry saw the same united stand with her parents; the impact of their fidelity lived on in her mother's stories. John's early family life was traditional; his father ran the business and his mother took care of the home and children. But the strongest impression his parents made on him was their abiding respect for each other. This quality, more than any other, informed his own attitudes once he was married. It was respect for his wife and her political passion that made him a supportive partner throughout Gerry's political life—even her ill-fated final run for U.S. senator from New York in 1998. John and Gerry managed to make that rugged campaign an opportunity to be together. He served as her willing chauffeur, and as they traveled from one end of New York State to the other, they talked and laughed like school kids on an adventure. They also shared a genuine pride in what they had achieved together. When the votes were tallied on primary night, and Gerry knew that she had lost, she and John greeted the press together, holding hands, surrounded by their family. Others might have been crushed by the defeat, but they were old pros at political defeat. The victory that most mattered was their enduring love.

LINDA FAIRSTEIN AND JUSTIN FELDMAN

Sweet Mystery of Life

Alexandra Cooper, the heroine of Linda Fairstein's best-selling mystery series, is the chief assistant district attorney of New York City's Sex Crimes Prosecution Unit. Since that's the position Linda herself holds in real life, she is often asked if Alex is her fictional alter ego. Linda delivers her standard reply with practiced aplomb: "Alex is younger, thinner, and blonder, and I've endowed her with a trust fund that allows her the freedom a young prosecutor could never have on our salaries." However, she acknowledges, there is a basis of reality in her character and in the plots of her novels. Anyone who has followed Linda's career realizes that the strongest similarities lie in the passion for public service and the compassion for women who have been the victims of assault.

When Linda, fifty-three, met Justin Feldman, she had been running New York's Sex Crimes Prosecution Unit for ten years, pioneering in a field of criminal law that had no precedents and no models. Her work was at the same time fulfilling and draining. It involved heart-sinking, middle-of-the-night phone calls that led to brutal crime scenes, hospital emergency rooms, and the morgue; exhaustive prosecution efforts; many victories, some defeats. In addition to fighting the criminals, Linda had to wage a daily battle against public ignorance about sex crimes. She had to shake people loose from entrenched notions that women invited rape by their behavior, the way they were dressed, or simply by being in the wrong place at the wrong time.

She was not, however, "married" to her work. During that time, she had a number of relationships,

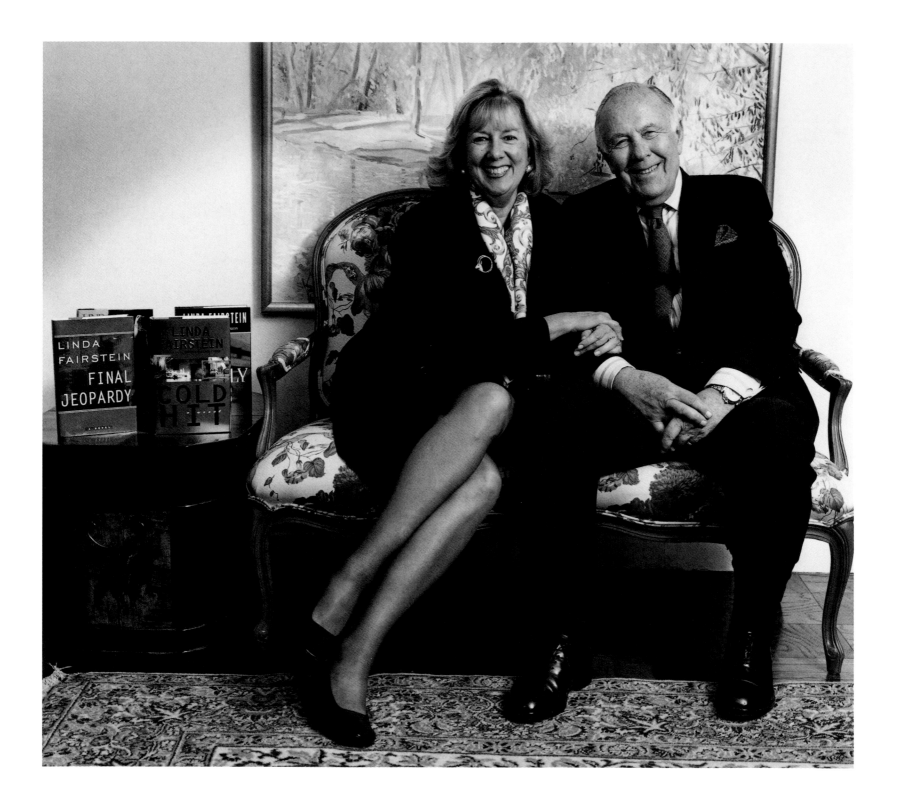

including a whirlwind ocean-hopping courtship with a Frenchman. "I made the decision that it had been a lovely romance, but not a commitment that I wanted to make for the rest of my life," she says now. "My parents had a wonderful marriage, and I just wasn't interested in settling. So I had a career, but I always wanted an interesting, fulfilling relationship. By the way, this was during the period that *Time* magazine published its famous report saying a single woman my age had as much chance of getting married as she did of being kidnapped by a terrorist. I remember friends calling it to my attention. But I was happy with my life."

When she met Justin Feldman in 1985, he was a prominent attorney, chairman of the Judiciary Committee of the Bar Association, and twenty-eight years her senior. Separated after thirty-seven years, Justin had married young and raised three children. Now in his late sixties, he certainly wasn't looking to get married again. The first time he called Linda, it was to invite her to represent the D.A.'s office on the Bar Association Committee. He had never met her, but she came highly recommended. Linda accepted, and they became casual friends.

The turning point for them happened on a day that a young Columbia University student was assaulted in her dorm, stabbed five times in the chest by her perpetrator. Linda worked the case feverishly, and late in the day, when she visited the hospital, she learned that the student was not expected to live. The news deflated her. No matter how many times she faced the brutal circumstances of a rape or a murder, it always made a devastating impact. She walked out of the hospital, feeling tired and discouraged, her feet dragging on the pavement.

There was a Bar Association Committee meeting that evening, and Linda arrived late. As she poured herself a club soda, Justin came over and put a hand on her shoulder. "I hear you had a bad day," he said. "Are you okay?" She nodded tiredly. "Do you want to have a drink after the meeting?" She shook her head. "No, I'm exhausted. I think I'll just go home." But later, as they were walking out together, Linda turned to Justin and said, "On second thought, a drink would be very nice."

They went to the bar in the Westbury Hotel and talked for two hours. As she unloaded about her day, Linda began to feel her tension lifting. It was nice to have someone to talk to who understood without judging.

The attraction, which had been hovering in the background, grew quickly. "I was old enough to know when it was right," Linda says.

"I was shocked when I realized that I wanted to marry her," Justin says.

"I didn't put a gun to your head," Linda jokes.

"Oh, no." He smiles broadly. "It's just that the age spread was substantial, and I never thought I'd be married again. But I loved her, and I wanted to be with her for the rest of my life."

In 1987, as Justin and Linda prepared for their walk down the aisle, the whispers began. "Not that much was said directly to our faces, but we heard later that people were alarmed by our age difference," Linda says. "When a friend expressed concern to me about it, I almost couldn't grasp her meaning. Justin was so vital and engaging and vigorous and curious. I never had a sense of the number of years. It may have sounded huge to other people, but Justin and I were in it together—we were just us. We were friends, we loved each other. I'd been out there. I knew when I met somebody that I was very happy to be with all the time. Even our interests were the same. It was so easy for me."

Justin and Linda were married in May 1987, but they didn't exactly settle into domestic bliss. Five days after the wedding, Linda began the murder trial of Robert Chambers, who had strangled a young woman named Jennifer Levin in Central Park in August 1986. It became the most high-profile case of her career—the so-called "Preppy Murder."

Linda lived that case day and night. The trial was a media event. Not only did it involve upper-class kids, it also involved sex, and the tabloids loved it. Chambers's defense team put Jennifer Levin on trial posthumously, building its case around the suggestion that it was her taste for "rough sex" that led to her death.

Although Linda could not share too many details with Justin, having him there at the end of the day was both comforting and energizing. With Justin, she didn't have to talk about it. He knew what she was going through, and he helped her set it aside for the few hours they were together every day.

The synchrony has continued. "We feed off each other," Linda says. "We like to be with each other. We read the same things. We have the same friends. We call each other at all hours of the day—'You'll never guess what just happened . . .' 'Did you hear . . .?' We're both very emotional people. We both well up with tears at the same kinds of things. It's always interesting and it's always fun.

"People often talk about how you have to work at a marriage," Linda says reflectively. "That's true, but I don't think working at it is enough. When you find someone whose interests and intellect and sense of joy meet yours on so many levels—that's pure luck."

Justin smiles in agreement, then his face turns wistful and he says quietly, "I love Linda, and our life together is more than I could have imagined. But let's be honest. It's bittersweet, too. I'm eighty years old. I'm not going to be around forever."

"Still," Linda says, meeting his eyes, "there are things in life that are just great good fortune. You don't question it. You live it."

ADOLPH GREEN AND PHYLLIS NEWMAN

On the Town

THE COMFORTABLE, CROWDED living room of Adolph Green and Phyllis Newman's West Side Manhattan apartment is casually strewn with memorabilia of a lifetime spent in show business—the original composition Leonard Bernstein wrote for their wedding forty years ago; a drawing of Charlie Chaplin by the poet e.e. cummings; dozens of Hirschfield illustrations depicting the musicals for which Adolph and his partner, Betty Comden, wrote lyrics; photos and notes penned by luminaries from Laurel and Hardy to JFK; stacks of sheet music; and awards.

Adolph has been making music as an author and lyricist for going on sixty years. He and Betty Comden still work every single day—Adolph traveling the few blocks to her Lincoln Center apartment. He is quite a bit older than his actress wife, but in forty years together, Adolph and Phyllis have synchronized their style and wit to the extent that the difference in their ages seem to have evaporated.

They met when Phyllis auditioned to be Judy Holliday's understudy in the Broadway production of *The Bells Are Ringing*. The way Adolph tells it, "When she came in, we were just leaving. We'd already picked somebody. Her agent had found her wandering the streets, and asked her why she wasn't at the audition."

"I hated auditions," Phyllis explains. "They scared me, so I wouldn't show up."

"We were very impatient at first, and then we were intrigued," Adolph recalls. "We let her go on for forty-five minutes, and when it was over, we wanted her very much."

Over the years, Adolph and Phyllis have elevated their everyday banter to the level of a Broadway musical comedy—complete with music. Adolph occasionally interrupts the dialogue by bursting into a few bars of "Singing in the Rain." With the snappy pace of a well-rehearsed duo, they tell their story.

Phyllis: Before I went out with Adolph, I memorized titles and passages from books so I could impress him. I upped my reading from Jackie Susann to Jane Austen; from Irving Wallace to Wallace Stevens. We went to Sardi's, and I kept saying things like, "That reminds me of the Wallace Stevens line . . ." or "As Marcel Proust once wrote . . ." I wanted to convince him of my intellect and sophistication.

Adolph: I was convinced of one thing—that she was gabbing a lot.

Phyllis's eyes gleam with excitement as she describes the wonderful world she entered with Adolph.

Phyllis: He had been married, and he was set in his ways. I was young, and excited, and fresh.

Adolph: Also fresh with my friends. They were crazy about her.

Phyllis: Adolph came with baggage, but what baggage! Lenny Bernstein, Betty Comden, Judy Holliday.

Do they have compatible temperaments?

Adolph: We have adjustable to all sizes.

Phyllis: You mean, do we get along? I don't think so.

Adolph: Well, sometimes we want to slaughter each other, and other times we have tremendous fun, and that's better than plain old compatible.

A big part of the fun has been their children. "I took to motherhood like a duck to water," Phyllis says. They both glow with pride when they talk about their son, "a wildly talented writer," and their

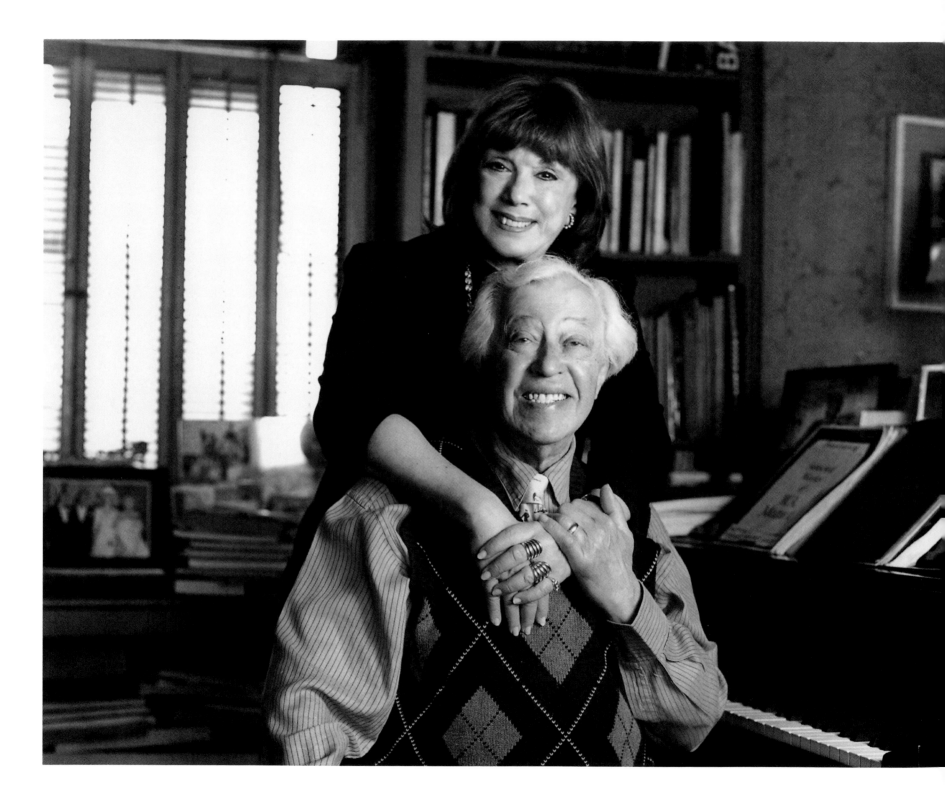

daughter, a professional singer and songwriter. Adolph says, "The four of us share this tremendous sense of humor and great intellectual curiosity. That's big stuff when it comes to staying together."

"As tough as it gets, we can make each other scream with laughter," Phyllis says.

Why are they still married after forty years?

Phyllis: That's a good question. I have no answer.

Adolph: That's life, I guess.

Phyllis: True.

Adolph: There it is, and that's it.

Then Adolph has to leave—off to work with Betty Comden. "Why would I stop?" he asks rhetorically. Like marriage, he adds, "It just is."

GOVERNOR MARIO AND MATILDA RAFFA CUOMO

The Magnificent Journey

Matilda cuomo still remembers the look on Mario's face when she told him that she could never marry a baseball player. "Like I had punched him," she says now, several decades later. "But in those days professional sports wasn't a bright, shiny existence. It was a nomadic, gypsy kind of life. It was no way to raise a family."

Mario Cuomo had always dreamed of playing baseball, and he had some talent. He could've been a contender, as they say. But he never got out of D ball. He went to law school instead, and married Matilda Raffa.

That's the short version. Anyone who has watched the former New York governor, listened to him speak, or read his writings knows that nothing is ever that simple for him. Life's questions are richly imagined and eternally mysterious—like the Chinese boxes that open upon smaller and more intricate boxes. It was this quality that first attracted Matilda, who thought Mario was "serious, not goofy." She had never met anyone like him.

When he first laid eyes on Matilda Raffa, a student at St. John's University Teachers College, Mario already knew that the competition was daunting. "Every big shot was after her," he recalls, with the confident air of the ultimate victor. "This one guy, he was very wealthy, good looking, a big sportsman—he was talking about this girl he'd taken out the night before. 'Matilda's so pretty, so nice. But

she wasn't very friendly. And he points her out in the cafeteria. I said to myself, if she doesn't want anything to do with him, I'm interested in her. I went right over and introduced myself—bought her a cup of coffee."

That began months of meeting in the cafeteria, talking. They both remember those long conversations about everything from religion to the death penalty. It may not sound romantic, but it was, and more than just romantic. Call it the coming together of two very passionate, curious minds.

Matilda had plenty of beaux, but Mario was the one she knew she could trust with her life. And almost as important as her own feelings was her mother's strong approval. "In our generation, we cared about what our parents thought," Matilda says. "If my mother had given me an inkling that she didn't like him, that would have made a difference. But the fact is, she liked him *so much* that I didn't understand it. I kept saying, 'Why, Ma?' And she said to me, *'Perche e sincero'*—'He is sincere.'"

Matilda agreed. Exactly. "Mario had a special quality. I knew I could trust him, right away, when I met him. There was no weak link. I knew we were really going to make it work."

As the Cuomos began married life, they represented the fulfillment of their immigrant parents' dreams. They had been educated in good schools, and they had formed a solid partnership. They looked forward to life together—the beneficiaries of the sacrifices of others. Beyond the low horizon of their parents' reality, there was nothing but possibility.

This immersion in a culture of commitment was a guiding force for Mario and Matilda, but their lives together began on a decidedly different note. Their world was an open place, an opportunity more than a burden. Not just an opportunity to be successful in a material way. That was never a priority for them. They wanted to make a contribution. First with children—five of them over the years. Next with public service.

"I never, never would have believed Mario would choose politics," Matilda says. "But I saw how engrossed he was as a young lawyer. He needed to help people." She laughs at the memory. "They often didn't pay him, you know. We had three children then, with little privacy and an abundance of homemade goodies and Italian tomato sauce."

The turning point for Mario was winning a public housing fight in Corona, Queens. People took notice of the fiery, brilliant young lawyer. But more important, that case cemented in Mario's mind the tangible connection between the good of the people and politics.

In political life, both Mario and Matilda found the fulfillment of their personal ideals—in the rare and wonderful opportunity to make a difference in the lives of others. When Mario was elected governor of New York, they presented a positive model of a political partnership. Reflecting on how much was accomplished during those years, Matilda says, "Women whose husbands are elected to public office have a tremendous role to play. Mario wanted my participation and he appointed me as honorary chairwoman of the Council on Children and Family. His administration accomplished so much in this regard. My husband's extraordinary leadership enabled New York State to create innovative programs and initiatives that are now being used as models all over the country. It's such a bully pulpit for what you care about. When you are given this kind of rare opportunity, a spouse can choose whether or not to be involved. I will always be grateful that as first lady of New York State, I had an opportunity to have access to influential policymakers to achieve our goals—particularly establishing the New York State Mentoring Program, the first one-to-one, school-based, statewide, K–8 mentoring program in the country. As first lady, I proudly lent my name to many worthy causes for their fundraising efforts and to create greater public awareness of important issues. In the process, I've been able to make a positive contribution to so many lives."

For the Cuomos, political life was grounded in the everyday hopes and dreams of the citizens. In politics Mario and Matilda found the opportunity to expand their partnership beyond the immidiate family. That takes leadership, a quality both Cuomos have in abundance. It is leadership as a communal dynamic—the ability to inspire and instruct others to be a part of their government.

Matilda continues to inspire women to take an active role in shaping their communities. "There's a place for every woman who wants to get involved," she says. "You never have to feel as if you've been left behind."

Today, as they look back on their years together, the Cuomos see their personal and public endeavors as part of the same unbroken continuum—the grand vocation of their lives.

"We all need something to believe in," Mario says thoughtfully. "For me, it was marriage to Matilda. This was something. And a family. Marriage for us was something significant. It was big enough to shadow all the other yearnings. It was sweet enough to overcome all the hard times."

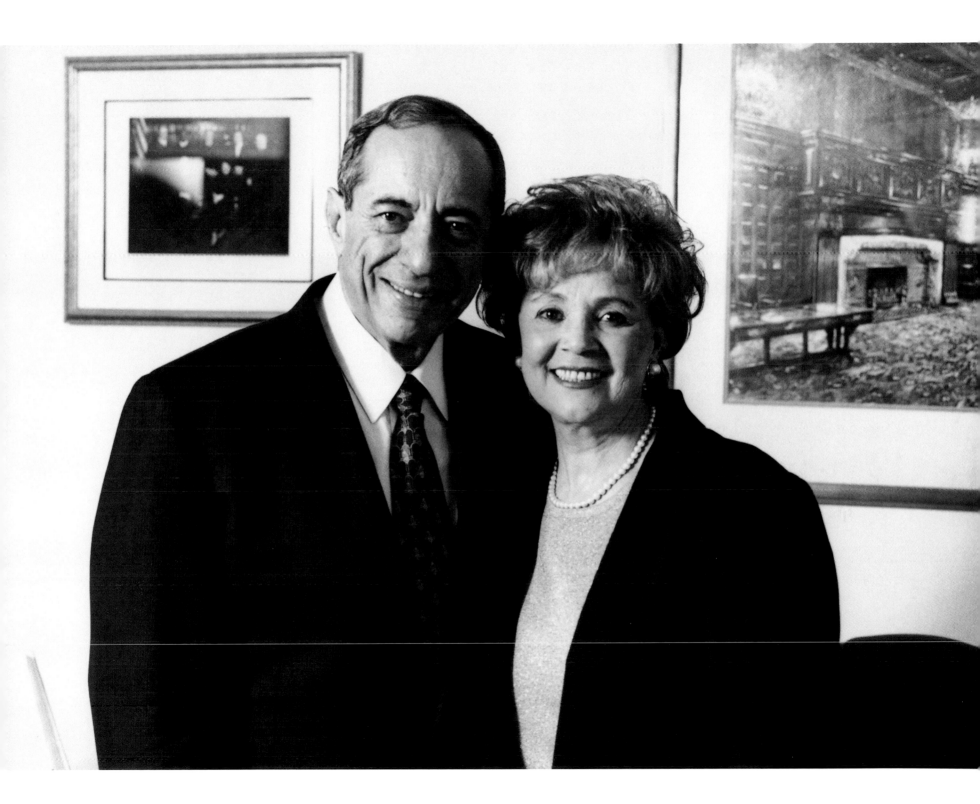

WARREN AND BARBARA PHILLIPS

⸺⸻⸺

Point-Counterpoint

W ARREN AND BARBARA PHILLIPS have a running debate, although it's not entirely clear what it's about. Take your pick—politics, religion, sex, feminism—they will take opposite sides. "We're *very* different," says Warren, arching a heavy eyebrow.

"Let us count the ways," Barbara drawls. "He's a northern boy. I'm from the South. He's Jewish, I was raised Methodist. He's conservative, I'm liberal.

So what's the attraction?

"It all comes down to sex." Barbara laughs. "And humor. And sometimes we want to kill each other, but that's *awfully* energizing."

After forty-five years of marriage, the pattern is set. Guests to their spacious home in Bridgehampton (which also houses their small but well-respected publishing house, Bridge Works) can always count on a lively discussion. It wasn't always thus.

"When I came along, I was just a peasant girl from the American South," Barbara says. "Warren thought he was getting a traditional Southern woman. Unfortunately, it was the time of Betty Friedan. I was radicalized by Betty Friedan." She laughs. "One thing I'll say for myself—I learn fast."

During those years, Warren was a rising star with the *Wall Street Journal*. Barbara was the supportive wife—raising the couple's three daughters and standing by him. "But during my Friedan period,"

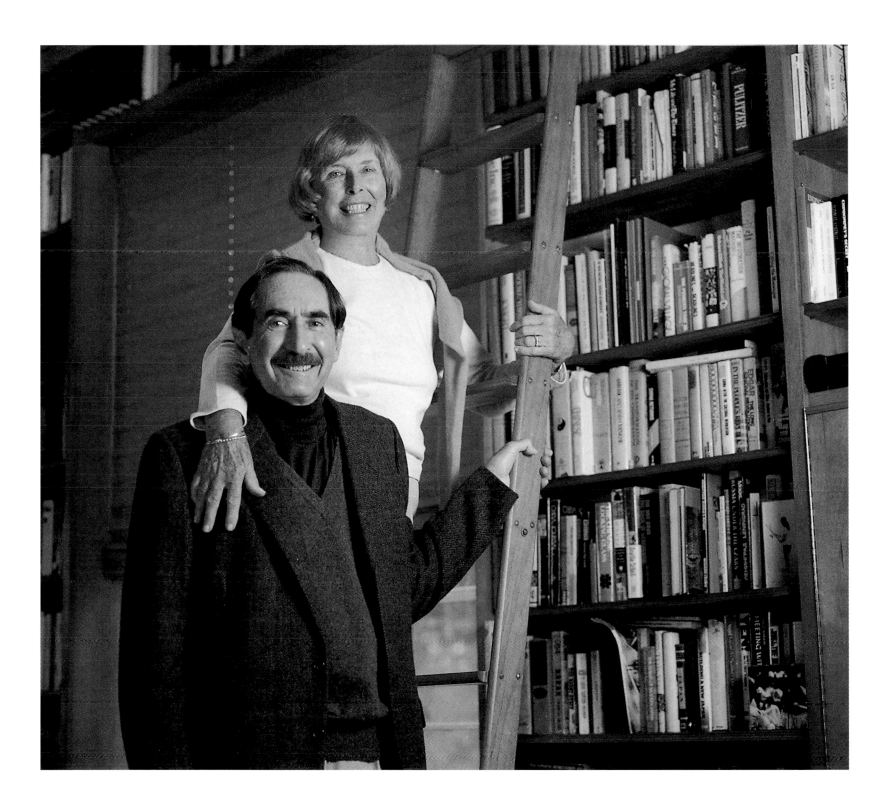

Barbara recalls, "I realized that there had to be something more to life than giving corporate dinner parties. We only go through this life once, and we need to stretch our own selves—not just be an extension of someone else."

It's hard to imagine Barbara ever being a shrinking violet. Regardless, today she certainly holds her own. It's fun to watch the Phillipses spar about the meaning of marriage and commitment.

Warren chooses his words carefully. "I think you have a better chance of making a marriage work if both people are somewhat introspective—if you bring a certain amount of thought and vision to bear. If one person is operating from instinct or emotion, and the other is thoughtful, trying to put things in perspective, it's more difficult."

Barbara leaps in, cutting off Warren's musings. "You can't really say that without sounding arrogant, pompous, and bathetic. . . ."

Warren's mustache twitches. "I have to give up a whole lifetime of sounding arrogant, pompous, and pathetic?"

"I didn't say pathetic. I said bathetic—bathos. Anyway, I don't think there's any one answer. The concept of family is bigger than that."

"Still," Warren presses, "somebody's got to explain where the glue comes from. Sure, you can say chemistry, sex, affection. But aside from feelings, the feelings of affection are based on certain very solid foundations, very solid groundings, and even when you're getting buffeted by things that aren't so great about the world, you can remain steady."

He goes on for a couple of minutes in this vein, building an intricate structure with words. One sees a glimmer of the analytical mind that contributed to Warren's success and led him to become CEO of Dow Jones & Co., which owns the *Wall Street Journal*, *Barrons*, and other publications. Barbara's way is different. Her face breaks into a wide smile, and her eyes sparkle. Squeezing Warren's hand affectionately, she says, "Let me translate. What Warren is saying is, give a little, and take a little, and say, 'My time will come.'"

Warren throws up his hands in defeat. "Not as pompous as my version, but basically, that's it."

And the round is over—for now.

WILLARD AND MARY SCOTT

Weathering the Storms

WILLARD SCOTT IS a genuinely nice person. He is a bear of a man who emanates warmth and congeniality and backs it up with hugs and kisses. A radio and television legend, he's been making America laugh for fifty years. He may also still be the best-known weatherman in the nation, reminding people to take their umbrellas and spreading birthday wishes to the most senior of citizens.

But what is it like to live with a man who gives a piece of his enormous heart to everyone he meets? A man who followed Larry Harmon as Bozo the Clown, and became the first Ronald McDonald? A man who once dressed up like Carmen Miranda for a TV broadcast? A man who has so much zest and energy that he seems forever "on" even when he's off camera?

Mary Scott has been married to Willard for forty years. She is an even-tempered woman with a quiet sense of humor, who placidly admits that it's been very good for both of them that they're not too much alike. She considers the question of living with Willard for a long moment, then replies, "Two days into our honeymoon, Willard got a call that he'd just won the role of Bozo the Clown on TV. We had to cut our honeymoon short so that he could fly out to California and attend Clown School. I remember sitting there at the hotel thinking, 'We just got married. My husband has left me—during our honeymoon—so he can go to Clown School. What have I done?' It was kind of funny. As a child I never liked clowns. They bothered me. And my husband was Bozo the Clown and Ronald McDonald."

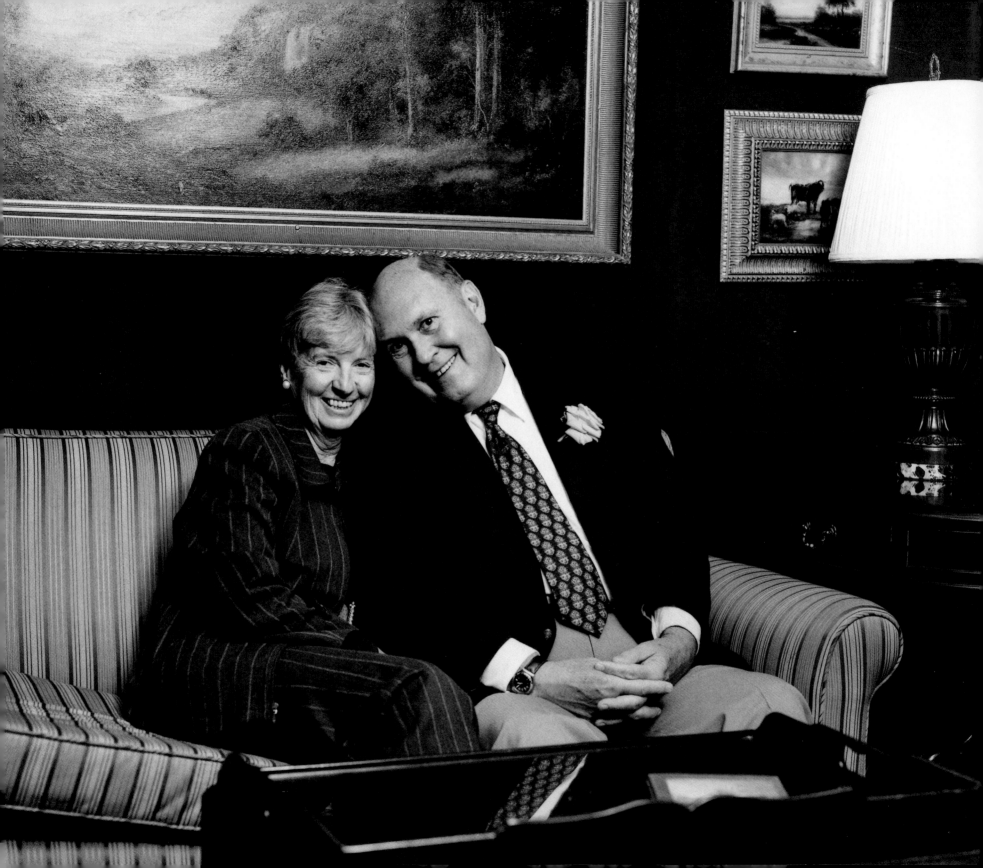

Sitting beside her on the sofa, the former clown in question laughs heartily. "Ah, that was really something. Mary was relieved when I started moving away from working as a clown to doing the weather. That happened when I filled in for the station's nighttime meteorologist. I decided to have some fun with it, and people liked it."

"People liked it." An understatement of grand proportion. Willard Scott may not have been a meteorologist, but people responded to him with tremendous enthusiasm. He was loose and fun, genial and warmhearted. He has always understood the weather, and the way its fluctuations mirror the ups and downs of everyday life. The skies may be gray, a storm may be brewing, but a smile, a laugh, a touching sentiment, has lifted generations of viewers right out of their doldrums.

Willard and Mary met at NBC many years ago. Mary was working in the traffic division. They liked each other, but Willard was engaged to be married. Then the engagement was broken off, and his relationship ended. Mary found out that he was free, got reacquainted with Willard, and the rest is history. They were married within six months.

"I felt so comfortable with Mary," Willard remembers, his face lighting up with a happy grin. "We relaxed. We had fun. There was no ulterior motive. As a young guy, every time I pursued a woman who was a heartthrob, I was always nervous. I could never relax, never be at ease. I couldn't be myself. With Mary, it was different. What Mary and I had was *real*. I liked that. I also loved Mary's parents a lot, and that was very important to me. I think you do marry the family, not just the person. It makes a big difference, especially if you have any problems over the course of your marriage. I remember that some years after we were first married, we were having a problem. When I complained to Mary's mother, she told me I could go to hell. She said I was completely wrong, and her daughter was one hundred percent right. I was stunned. I said, 'Ethel, I can't believe you're saying this. It's *me*, your son-in-law!'" He shakes his head, helpless with laughter. "That's how close we were."

Through all kinds of weather, the Scotts created a life for themselves, enjoying the fruits of Willard's success. At home in Virginia, they raised two daughters—"One is just like Willard, and the other is just like me," Mary observes—and when the *Today* show called some twenty-nine years ago, they moved to New York and loved it. They're now back in Virginia, and Willard is still a regular on the *Today* show, celebrating the lives of centurions and couples who have been married for seventy-five years or more.

The Scotts speak with refreshing candor about the ups and downs of their long marriage. Their

openness and honesty is remarkable, especially given the level of Willard's celebrity. Yet it is this very quality that endears him to so many people. The person they've seen on television for so many years isn't playing a role. He's utterly authentic. In matters of love and marriage, his insights can be razor sharp, and they are often the kinds of things people think but seldom say.

"Like everybody, we've had our problems over the years," he says.

Mary nods and adds with a chuckle, "People ask me, 'Is Willard always happy and joking, just like he is on TV?' I say, 'Oh, get real!'"

"The truth is," Willard says, "There have been four or five times over the years when we could have split up. But every time, when it reached that point, one of us got things back on track. I'm not talking about a big deal complete with apologies, or either of us saying, 'I surrender. I was wrong.' It was just that one of us stopped pouting and started talking. One of us raised the temperature in the room a bit. That's what saved us."

"It would never have occurred to us to end the marriage because we were having a problem," Mary adds. "Today, you see couples getting divorced over problems that are minor compared to what we've had. If you don't understand the idea of commitment, then there's nothing that will hold you together when you're having a rough time. But if you stay together, those rough times become a part of your history, and all of it, good and bad, is meaningful. It's wonderful to have a partner who is committed to you, and you see it most clearly at the very worst times in your life. When I was in my thirties, my father died suddenly. It was a horrible shock. I reeled from losing him for a long time. I also went through a rough bout with cancer. And Willard was always there. He was just incredible. To have him there for me—that was so valuable. Where else do you get that—a person who supports you, no matter what?"

Willard nods enthusiastically. "There's nobody I would rather be with for the long haul than Mary," he says softly. His eyes glisten, and his face is suffused with warmth. "I enjoy her company. I like being with her. Bob Hope's theme song, 'Thanks for the Memories,' says it all: 'You may have been a headache, but you never were a bore.'"

Willard and Mary laugh companionably, comfortable with each other, glad to be together to share this stage in their lives. Willard adds a final thought, a gibe that combines his good nature with his genuine charm.

"And when she gets tough, and hard to live with, and bossy, I *still* like her!"

AVERY AND JUDY CORMAN

Anticipation

Tᴇɴ ʏᴇᴀʀs ɪɴᴛᴏ his marriage, Avery wrote *Kramer vs. Kramer*. It was so original, so deeply felt, it was naturally assumed that the author was speaking from someplace in his own experience. That was true. But what moved Avery was not a broken marriage; he was committed to Judy. "You'd be hard pressed to find a second of our marriage in that book," he says. Rather, the motivation was that he had just become a dad.

"I felt that there was something ignored in the whole stew of things at that time," Avery says. "And that was the male feeling toward children. I thought that men had been sort of pushed aside. *Kramer vs. Kramer* was really about that."

As far as the commitment to their marriage, now approaching its thirty-third year, those were very unsettled times in society. Many of their friends were getting divorced. Others were shunning marriage altogether. The age of self-actualization was in full swing, and there they were, keeping on. "The sands kept shifting," Judy says. "But we kept making the commitment."

"There was a lot of fallout from the raised consciousness of the sexes," Avery says. "All around us people were questioning whether marriage meant anything. I remember I had a friend who wasn't married—he didn't know if he believed in the institution. And he kept gaping at us in amazement. Not only did we get married, but then we had a kid, and then we had another kid, and he was still sitting on the sidelines watching."

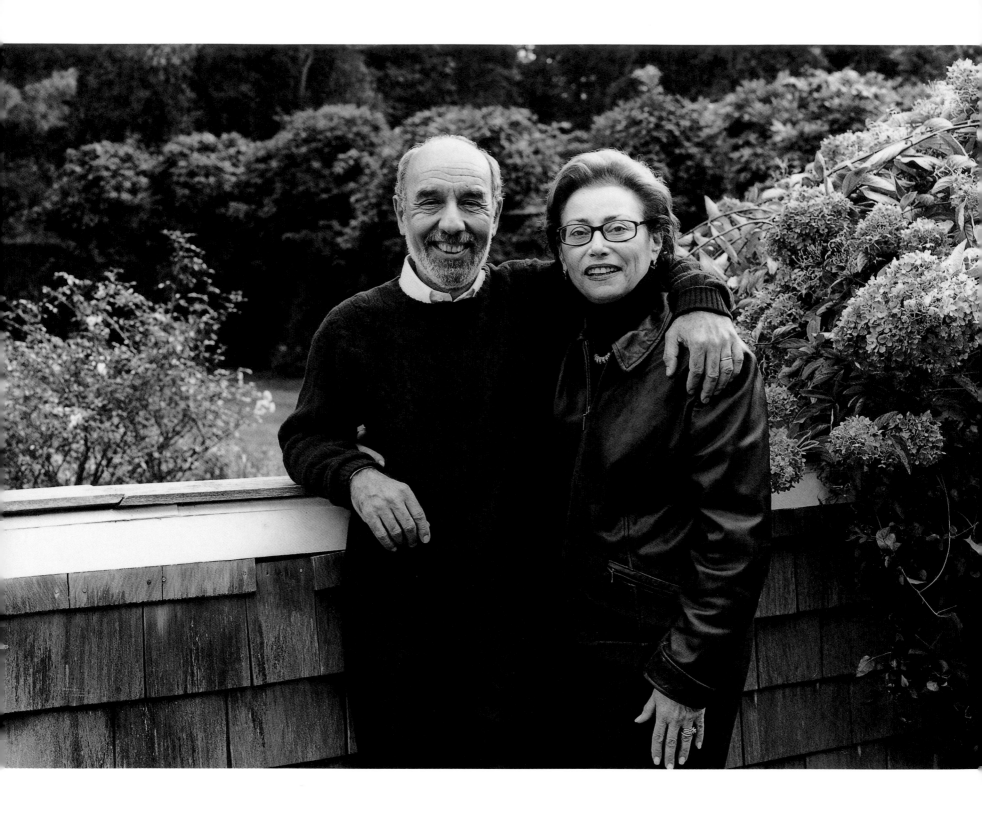

Mind you, during the time Avery and Judy are describing, they had none of the acclaim they enjoy today—he as a famous author, and she as one of the top publicity directors in publishing. They were young and creative, but struggling. As they look back, they share a theory about how they got through the crisis times—and there *were* crisis times.

Avery puts it this way: "During the crisis times, one of us was always prepared to say, 'No, I'm not willing to throw in the towel. I love you.' So the other one held on. If both of us had said, at the same time, 'Oh, well, what the hell,' it would have been over. There were times when each of us had one foot out the door. Luckily, the other one remembered why we married each other in the first place."

Avery and Judy clearly have very different styles. He can be painfully quiet and thoughtful, although he possesses a dry humor that creases the laugh lines around his eyes. Judy, on the other hand, is animated and vivacious—almost girlish. But they just seem to fit. They're in sync. "It sounds fancier than I mean it to," explains Avery, "but there's a literary sensibility that is very refined between us. We 'get' the same things. It's old-fashioned to say it, but politically, and aesthetically, and literarily, and musically we share a very similar appreciation. Psychologically and emotionally, we may be markedly different and are. But in those other areas, I think we're remarkably similar. And maybe that's what happens after years in a marriage."

"Not that we're clones," Judy hastens to add. "Our personalities are very unique and defined. Even from the start, there was never any doubt that either of us was going to get lost in this marriage. We're very strong-willed individuals."

With their children grown, Avery and Judy laugh at the idea that they've reached a point of kicking back. "This notion of the golden years is ridiculous," Avery says. "They show people walking along the beach—they always seem to be walking along the beach or in a rowboat. Not us. Our days are full and productive."

They anticipate many more years of full engagement in their work and their life together. And when they contemplate all that they've been through, and the fact that they've made it work for thirty-two years, it seems like the blink of an eye.

"Thirty-two," Avery muses. "It's not shocking. It's not even dramatic. Now, *fifty* . . ."

REVEREND JAMES A. AND BETTYE F. FORBES

Not Done Yet

Tʜᴇ ᴍᴀᴊᴇꜱᴛɪᴄ ꜱᴘɪʀᴇꜱ of Riverside Church and its massive building are a stirring sight. Sitting like an elegant gothic watchtower over the northern end of Manhattan, the church soars twenty-one stories into the city's sky, an abiding symbol of the power of faith and the devotion of community.

Within the impressive, beautifully ornate interior of this huge church, there is a wonderful feeling of good: a spiritual environment of warmth and caring. As sunlight streams down on him through enormous windows of exquisite stained glass, the Reverend James Forbes calls upon his congregation to lay claim to the power within them, and so obviously surrounding them. The Reverend Forbes is an electrifying speaker, an admired African-American leader, and a key player in the civic pageant of New York City.

Away from the pulpit, he is a slight, handsome man, with a soft voice and a deliberate, thoughtful manner. His elegant wife, Bettye, a musician, is as soft spoken as her husband. Her dignified carriage further adds a measure of size to her delicate frame. They live across from the church, in an apartment at the Union Theological Seminary. The Forbes's apartment is an airy jewel, a meditative space that features many of the beautifully crafted, old-world elements of the seminary itself. It has been leased to the Forbes for as long as they remain at Riverside Church. If a time comes when they move on,

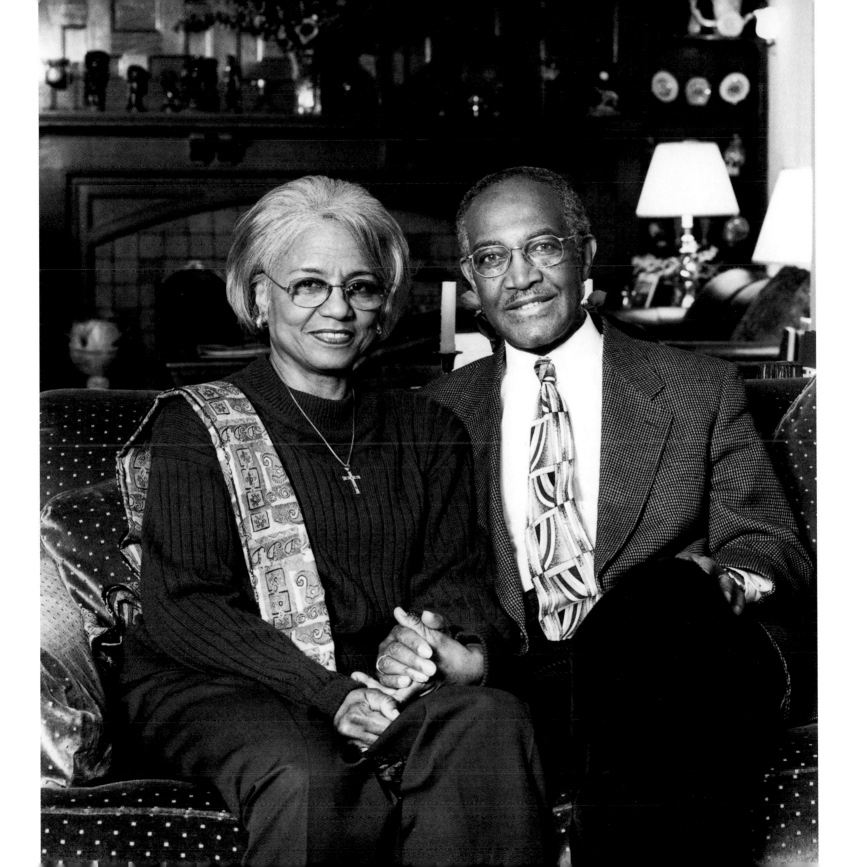

they will do as they have done several times in their lives—start from scratch, making a home else-where. The riches in their lives are decidedly not on the material plane.

James Forbes was born in a small town in North Carolina, the son of a preacher. He and his seven siblings were raised in a stable and rigorous household by parents who expected performance, not excuses. "When I was a boy," James says with a smile, "people would ask, 'Jimmy, are you going to be a minister like your daddy?' I always said no. I wasn't about to do that." When he began college at Howard University in Washington, D.C., he had already decided to study medicine and become a doctor.

It was a good thing James Forbes sang so beautifully. He first set eyes on Bettye when they were in the choir together at Howard University in Washington, D.C. James sang bass and Bettye sang alto, so their sections were quite a distance from each other.

Still, James remembers that he saw Bettye right away. "I certainly thought she was attractive. A friend of mine got after me to ask her out, but I thought she was too swift for the likes of me," he says, adding with a molasses-thick drawl, "I was just a hick from a little town in North Carolina. She was a musician from Texas, who used to play at night clubs." So, although he certainly knew who Bettye was, James didn't ask her out at that time.

Then serendipity took a hand in the young couple's fortunes—or maybe it was simply God's plan. After a spiritual reawakening had led James to abandon plans for a medical career and take up the ministry, he returned to North Carolina to become pastor of a church in Wilmington. A year after his return, while attending a church convocation, he spotted Bettye among the congregants. James was pleased to see her again. "I sat down next to her and gave her my most brilliant line," he laughs. "'Haven't we met before?'"

Bettye smiles fondly at her husband. "I really had no idea who he was. But then, as the service was about to end, and we began singing the closing hymn, I realized that I had heard that voice before. And, hearing his voice, it all came back to me. Then I remembered him perfectly well."

Bettye was a teacher in Aden, North Carolina, which was a good two-hour drive from Wilmington. "The first thing I did was invite myself to her house for dinner," James says. "One hundred miles away." What followed was a long-distance courtship, with James tearing up and down the highways between Aden and Wilmington on many nights. The commute lasted only six months. In June 1964, marriage intervened.

"I never thought I would marry a minister," Bettye offers, even now shaking her head in amazement. "I had my own ideas of how it would be. Rigid. Strict. But James didn't seem so strict. He was different. And we both had the same values. It just seemed right."

A year after they married, James accepted the pulpit at another church, and they moved out of Wilmington. They were both happy with the move. As James diplomatically remembers, "When I was a young, single minister, I was being sized up as potential husband material by both the mothers and the daughters of the church I served. Once I was no longer single, I quickly realized that it would be best to move on." Unspoken is the implication that there may have been some displeasure at the young pastor's decision to marry a woman from outside of his congregation.

James and Bettye have one son, James, who is a tribute to both of them. He is a minister and a musician, drawing from the strengths of each of his parents. They are clearly proud of him.

James relies on a secular source to describe the basic philosophy of their marriage. "It was M. Scott Peck who wrote that 'The purpose of marriage is friction—to wear down the jagged edges of your own egocentricity.' I like that image of friction. Our love manifests itself, not through commonality in all things, but in accommodation to our differences."

As they go through their days, James and Bettye are conscious of a light that surrounds them. It is not vanity—the light is not of their making. But it is very real. "We have never perceived ourselves as being special," James points out. "However, others who see us perceive that we are a most unusual couple—a symbol of love and caring and stability. It happens all the time. We'll be stopped on a bus, at the grocery store, in the department store, going down the subway steps, and people will say, 'You certainly are a nice couple.'"

When James was a young man, in the throes of making his vocational decision, he heard a minister give an impassioned sermon. "What do human beings have in common with biscuits in the oven?" the minister boomed. He paused a beat before replying, "They're not done yet."

After thirty-six years of marriage, James and Bettye have the pleasure of knowing that they too aren't done yet. New adventures still await them. There will be opportunities for further enrichment. The Forbes will travel wherever life's path may lead them. Willingly. Together.

RICHARD REEVES AND CATHERINE O'NEILL

Change, Change, Change

ON THEIR TWENTIETH wedding anniversary, Richard Reeves and Catherine O'Neill rented a castle in Italy for a week. Joining them were their children, their grandchildren, Richard's brother and sister-in-law, Catherine's sister and brother-in-law, and various cousins. There, on the castle's terrace, surrounded by their loved ones, with the brilliant summer sun shining down on them, they renewed their vows.

As they celebrated their union, Catherine found herself thinking back to the day of their wedding, remembering something Richard had said to those gathered: "I have fought more with this woman in the last year than I have fought with, cumulatively, all of the other people in the rest of my life." She smiled to herself, realizing that they had worked out a lot of the old kinks. They didn't fight as much anymore.

Of course, there *was* that time in Morocco, when an argument grew so heated that Richard got out of the car and started walking across the Sahara. But overall, well, they'd mellowed.

If mellowing means moving, exploring, experiencing, and never settling into a rut. Richard likes to say, "Marrying Catherine was like joining the Navy. I saw the world." It's true. The theme of their marriage seems to be "on the road again." They've been around the world three times, including a memorable thirty-four-day world tour in 1995, with three children, their children's spouses, and a baby in tow. They wrote about their experiences in *Family Travels: Around the World in Thirty (Or So) Days* (Andrews McMeel, 1998).

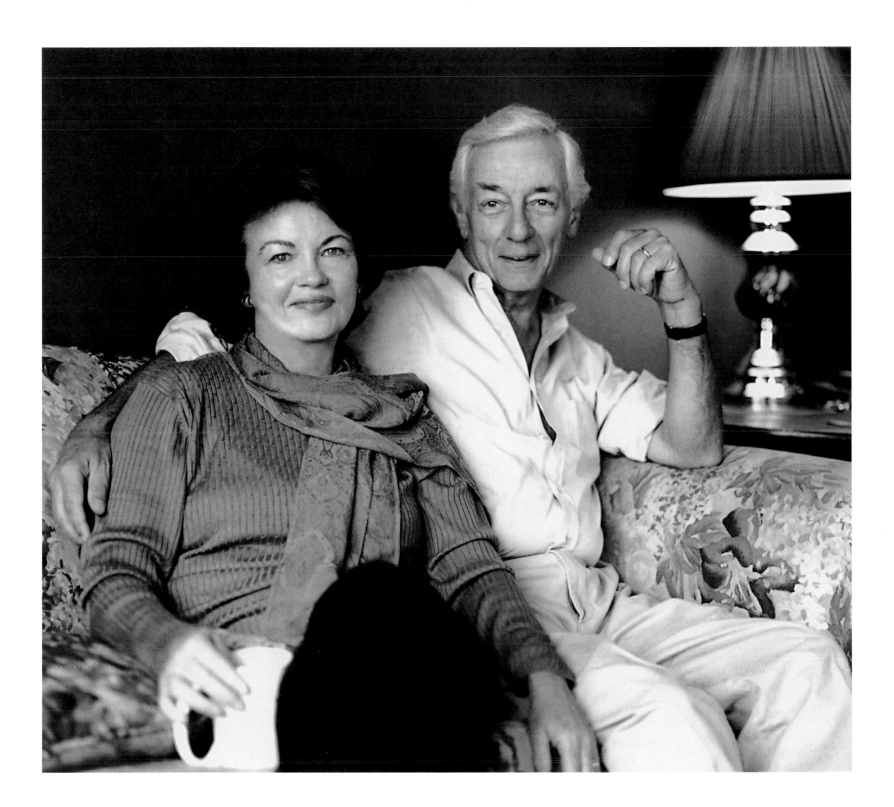

They've also varied their home base over the years—living in California, New York City, Washington, D.C., and Paris. Richard, a well-respected political writer (*President Kennedy: Profile of Power*; *The Reagan Detour*; *What the People Know: Freedom and the Press*) is currently at work on a book about Richard Nixon. Catherine has a high-profile position as director of the United Nations office in Washington.

They met in L.A. in the 1970s at a cocktail party for *Esquire* magazine. Richard was a forty-one-year-old divorced father of two, living in Washington, D.C., and working as the national editor of *Esquire*. Catherine, thirty-six, was a divorced mother of two, living in Los Angeles, and working as editorial director for the Westinghouse Broadcasting Company.

Unlike many divorced people, Richard and Catherine had no deep fears about recommitting. In fact, Catherine has a very definite perspective about the meaning of their divorces. "I have to tell you," she says, "I don't really feel that divorce is necessarily a failure. When you marry young, you're unfinished, unformed. Neither of you know how you'll emerge in your adult life. And if you grow apart, it's not failure, but a recognition that different people don't always grow in the same direction. Maybe they're not meant to be partners for the next thirty or forty years."

Meanwhile, Richard was looking for a commitment. "I felt a life without family was incomplete," he says. "And I wasn't interested in living with someone. At a certain age, you have to act like a grown-up. I didn't want to be going around in my forties and fifties using words like *girlfriend*."

Neither anticipated having a child together, but seven years after they married, Catherine became pregnant with their daughter, Fiona. Not surprisingly, having an infant along didn't slow them down in the least. When Fiona was barely four weeks old, they packed up and moved to Paris for four years.

The one constant in the lives of Richard Reeves and Catherine O'Neill has been movement. For Richard, the secret is simple: "Marry a smart woman." When Catherine laughs, he presses his point forward. "Seriously, you're going to have to live with this person, and if she's smart, you'll have something to talk about every day. There are a lot of men and women who don't have anything to talk about. They stop growing, they stop experiencing."

"Well, that's true," Catherine agrees. "It comes down to change. I've always thought that getting old is when you know nothing else is going to change. There are no more surprises in store."

If that's the case, Richard and Catherine have found the secret to eternal youth.

WINSTON AND BETTE BAO LORD

A Living Mosaic

"I'M AFRAID WE'RE terribly dull," says Bette Bao Lord apologetically. She's worried that the Lord marriage is too harmoniously uneventful to be featured in a book about couples.

Hardly. For starters, how did Winston, a self-described Park Avenue WASP, and Bette, a Chinese immigrant born in Shanghai and raised in Brooklyn, get together in the first place? What did they have in common?

Winston and Bette met in 1959 when they were graduate students at Harvard University's Fletcher School of Law and Diplomacy. When Winston spotted Bette at a school dance, he was instantly drawn to her. She radiated dignity, beauty, intelligence, and mystery. For her part, Bette was equally taken with the tall, gangly young man with the dry wit and the encyclopedic knowledge of international affairs.

For the following year, the two were inseparable. They were deeply in love, and they found themselves a perfect match in mind and spirit. However, this was the 1950s, and surely they must have endured some difficulties in the racially charged environment of the times. "Not really," says Bette. And, she adds mischievously, "our families insisted."

"My parents would have disowned me if I hadn't married Bette," Winston concurs.

Well, that's a switch. But you have to understand something about Winston's family. Although they

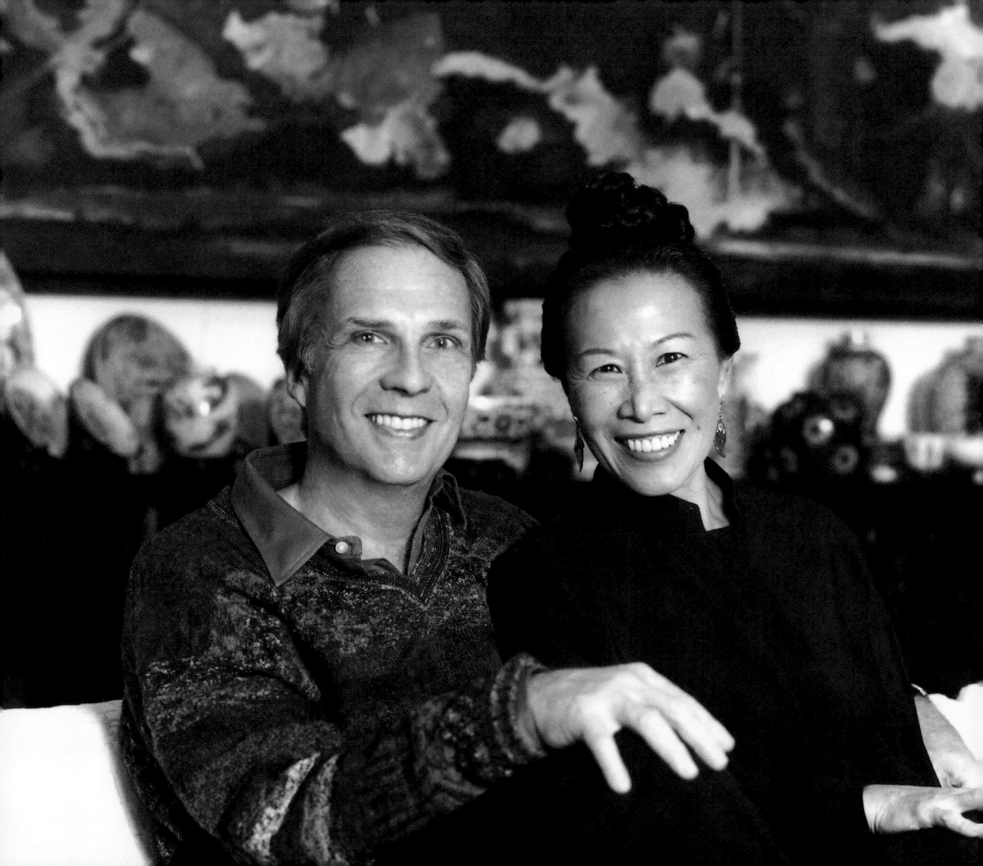

lived on Park Avenue and were, strictly speaking, WASPs, they were also quite remarkable. Winston's mother, Mary Pillsbury Lord, was a prominent figure in international circles. At a time when few women were anywhere to be seen in positions of authority, Mary Lord served as a United States delegate to the United Nations, and as the U.S. representative to the U.N. Human Rights Commission. Winston was raised in an environment devoid of racial stereotyping, by a mother who was a model of strength and intellect. Their spacious apartment was filled with books and artifacts from all over the world. It seemed natural for Winston to follow his mother into the fascinating and fulfilling world of international affairs.

Winston and Bette experienced none of the possible points of conflict a mixed marriage would suggest. The only hurdle to their union was the necessity of getting married in Washington, D.C., instead of Virginia, where racially mixed marriages were still frowned upon.

Seeing Winston and Bette today, it is difficult to believe that they have been married thirty-seven years. Winston's friendly, ebullient personality and his sparkling eyes belie the graying hair and the lines etched in his face. Bette is still quite beautiful. She has an ageless quality; her face is clear and unlined, her black hair piled in an intricate knot atop her head. Her smile is genuine—unaffected by wealth or success. The independent young girl she once was can still be glimpsed in her shining, open face.

They have always been equal partners—even in times when that was not conventional. It is likely that few foreign service officers or state department officials were rushing home from work to change diapers, but Winston always took his fair turn at the household tasks. "We established an equal division of labor from the start," he says. "That involved some role reversals. Bette took care of the finances, the taxes, the bills. Also, her father was an engineer, and she was handy around the house. I could barely change a lightbulb. My assignment early in our marriage was to take care of the kids' diapers and the dog. I genuinely preferred changing diapers to doing taxes, and Bette was the opposite."

The common thread that runs through their lives—and perhaps the one that holds them closest together, is the East. Throughout their marriage, each has felt the presence of the East in different ways—Bette through her writing, and the steady tug of her roots; Winston through a career that has included an ambassadorship to China. More recently he served as assistant secretary of state for East Asian and Pacific Affairs. In 1985, when President Bush appointed Winston to be America's ambassador

to the People's Republic of China, he and Bette lived in China for three and a half years, and became immersed in a culture that Bette found disturbingly foreign yet familiar. As she wrote so poignantly in *Legacies: A Chinese Mosaic*, a collection of stories about that period, her heart and mind could barely contain the conflicting pulls she experienced in her homeland. Her life, she wrote, had become too much like China itself, full of contradictions: "I worked and did not work. I had changed and I was the same. I had scores of good friends and none at all. I was celebrated and I was suspect. I was an equal partner and not even on the team. I was an insider and an outsider. I was at home and I was exiled. I had never been happier, nor had I been as sad."

It is this confrontation with what is known and what remains unknowable that pervades the Lords' partnership. It is exulting in both that makes their life together work so well.

JUDGE JERRY AND
JUDGE JUDY SHEINDLIN

For Better, or Forget It

THE FIRST TIME Judy Sheindlin saw her future husband, Jerry, he was holding court at Peggy Doyle's, a local watering hole in Lower Manhattan. He was a defense attorney, divorced, with three young children. She was a prosecutor in Family Court, divorced, with two young children. On this Friday, Judy had agreed to join some colleagues for a quick after-work drink before starting her long commute home.

Jerry was in fine form, colorfully relating the details of his great victory in court that day. Judy saw that he was handsome, somewhat cocky, and he told a mean tale. She strode over to where Jerry was sitting, stuck a finger in his face, and asked a colleague, "Who's this?" To which Jerry replied, "Get your finger out of my face, lady!"

So began a great romance. They married, brought together their respective broods—five kids in all—and embarked on a marital adventure that has had both highs and lows, but has never been dull.

Jerry and Judy are world-class kibbitzers, and they love a good fight. In her 1999 best-seller, *Beauty Fades, Dumb Is Forever: The Making of a Happy Woman*, Judy provides an entertaining view of domestic warfare, Sheindlin style, where heated debates are waged over issues of crucial importance to the future of the globe: changing the toilet paper roll, folding the laundry, picking up the dry cleaning, putting the toilet seat down, and planning dinner (takeout). Her account is more than a little tongue-

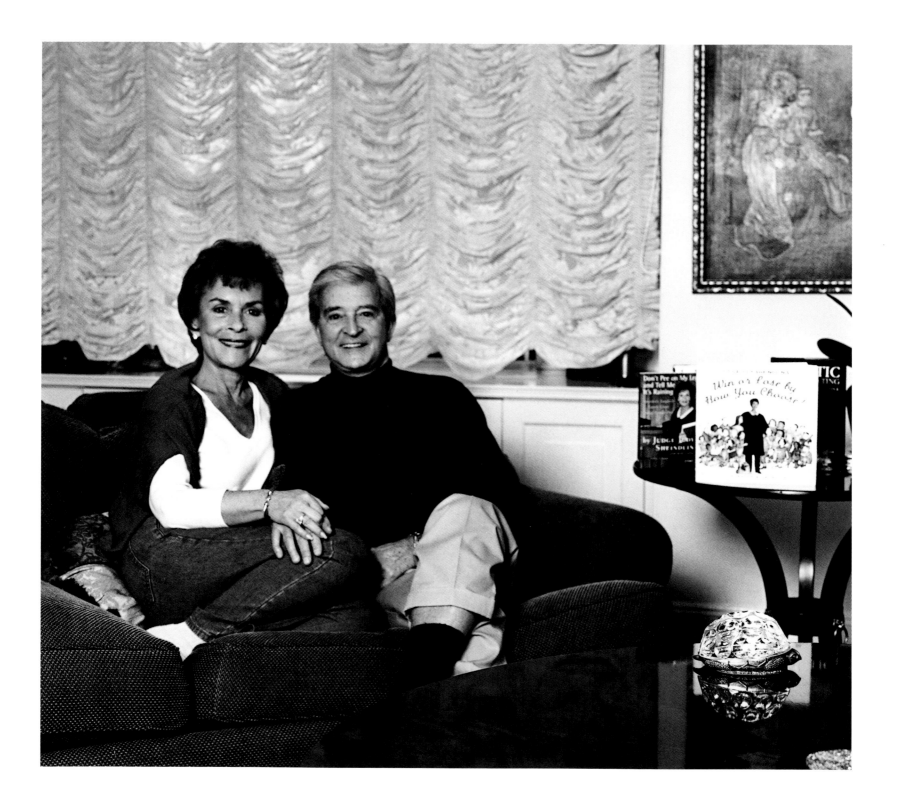

in-cheek, and it doesn't tell the whole story. The Sheindlins have a bedrock marriage, forged in the course of experiencing both "for better" and "for worse." Most of their marriage has been spent as hardworking civil servants—he a justice with the New York State Supreme Court, and she a New York Family Court judge. From their respective benches, they observed the cruelest sides of human nature—mothers giving birth to crack-addicted babies, young gang members killing people for kicks, and every heartbreaking saga in between.

The greatest challenge to their marriage came in 1989, after Judy's beloved father, Murray, died of an infection following heart surgery. Judy was grief stricken, and the marriage suffered. She is quite candid about what happened. "My father provided me with an unconditional love that gave me complete security," she says now as she looks back on that time. "Whatever I needed, he was there. Jerry and I loved each other, but I never felt as if I came first in his life. That was fine, as long as my father was alive. I was always first with *him*. But when he died, I wanted Jerry to be a different person—attentive, reliable, and more like my father. Essentially, I changed the rules after twelve years of marriage. I was relentless, and Jerry was angry."

"It became impossible to stay together," Jerry adds. They separated, then divorced.

In the year they were apart, Judy was forced to face several hard truths. "I saw that Jerry mistook my strong personality as a signal that I didn't need his doting and attention," she says. As the months passed, she realized that she and Jerry had something very special, and she missed him. "You just don't come across kind, funny, smart men like him every day—especially those who also have a full head of hair," she says, half laughing. Meanwhile, Jerry, given some distance, was starting to acknowledge that he'd been subtly neglectful. "I should have understood that Murray's death was a phenomenal blow to Judy," he says. "I wasn't paying enough attention."

Neither of them wanted to be apart, so each of them gave a little. The move toward the center in no way diminished the spicy edge that was a trademark of their relationship.

The Sheindlins were remarried in the office of Jerry's former law partner, now a judge. When he asked Judy if she "took Jerry for better, for worse, in sickness and in health, till death do you part," her response was classically Judy. "For better, or forget it!" she retorted. She meant it—but she was smiling.

The celebrity that has come to Judy as a result of her popular daytime court show, *Judge Judy*, is

just gravy on a life well lived. Jerry, who watched his wife's meteoric rise with pure delight ("I love being married to a very wealthy woman"), has joined her on the TV bench. When he retired from the New York State Supreme Court, he found himself reseated, as the new judge on television's People's Court, replacing former New York City mayor Ed Koch, who as mayor appointed both Sheindlins as judges.

Two judges, two television shows. Judge Judy and Judge Jerry may soon become two of the most famous judges in the world. But at home, when they have time together between Judy's every-other-week trips to the coast, they are unaffected by fame or money. They both get a kick out of the turn their life has taken, but they don't treat their success too seriously, and it doesn't define them. They still have dinner at their favorite pizza joint, and they still quibble about the same things—with minor exceptions. Now that they've upgraded from their previous one-bathroom apartment to a bigger place that allows separate bathrooms, Jerry is free to leave the toilet seat up to his heart's content.

BERT AND LETTY COTTIN POGREBIN

Common Threads

Aₛ ᴛʜᴇ ʜᴜsʙᴀɴᴅ of a woman whose name is equated with feminism, Bert Pogrebin sometimes gets asked if he would have preferred Letty to have been a less public and more traditional wife. Bert smiles his warm, slow smile, and pretends to contemplate the question seriously before replying, "Why turn a glamorous woman into Dorothy Drudge? One of my greatest vicarious pleasures is Letty's success."

Truth be told, Bert wouldn't know a traditional wife if he had one. His mother wasn't exactly a role model for the apron and apple pie set. As Letty says with a laugh, "Bert's mother was such a radical that living with a politically active woman seemed normal to him. Let's face it: He grew up with his mother standing on a soap box, preaching the Communist Manifesto. Nothing I did as a feminist or peace activist ever matched that!"

Still, Letty is a woman of tremendous achievement. She has authored eight books, including *Getting Over Getting Older*; *Deborah, Golda and Me*; and *Free to Be You and Me*, which she developed with Marlo Thomas. She is president of the Authors Guild and the recipient of many awards. Perhaps some men would be threatened by her visibility, but Bert has no such problem. Secure in his own success and comfortable in his identity, he clearly relishes his wife's professional achievements. He also takes great delight in being with a woman who still favors him with adoring smiles, even after thirty-seven years.

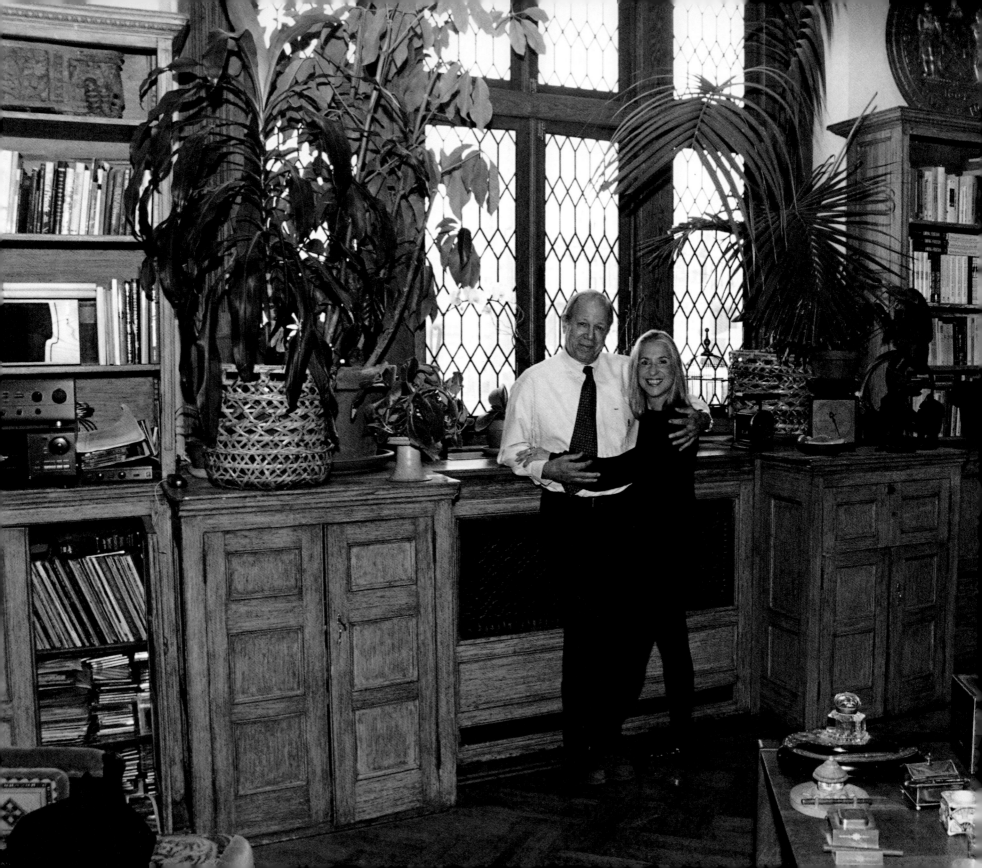

If an argument can be made for two people meeting their matches, based on an ideally arranged set of commonalities and attractions, Bert and Letty could be the poster couple. That isn't to say that their marriage is a treacly tale of perfection. Actually, they're both extremely strong and independent personalities. But as they recall the forces that shaped their lives, and what brought them together, the connections are plain to see.

When they met thirty-seven years ago across a volleyball net at a friend's beach house, neither of them was very radical, and Letty hadn't discovered feminism yet. As Letty says, "It was the sixties, but it wasn't the Sixties with a capital *S*." However, Letty does say this about the attraction: "First of all, he smoked Lucky Strikes, which was my father's brand. So I had all of these smell and look associations. Then, I found out he was in my father's fraternity. He knew the secret handshake! And we both had Communists in our families, so we'd been through the McCarthy era with a lot of *sturm und drang*. It's weird almost, because if you look at pictures of Bert's family and my family, you can't tell them apart—in terms of where they came from, and their style and economic level. I think it registered on a subliminal level."

These are some of the random memories that come to the surface. They do not even begin to explain the connection Bert and Letty felt, but it was strong enough that within six months of meeting they were married.

"Most of the common facts in our backgrounds didn't come out until after we were married," says Bert. "Maybe the commonalities acted as a a substitute for a long courtship. Whatever the reason, I was surprised that it was so easy to live with another person."

"Like something clicking into place," Letty adds. "It was surprising for me, too, to feel so unconflicted. I remember very specifically—one of those frozen moments—walking down the aisle and thinking, 'This is the rightest thing I've ever done.'"

Two years later, twin daughters were born, and three years after that, a son.

Life was never the same. "Before the kids came, it felt like we were single people on a continuous date," Letty says. "Then we were grown-ups."

The coming years involved a hectic melange of change, growth, and finding their professional identities. Bert became a prominent labor lawyer. Letty had a successful career as a book publishing executive, and then she started writing. "Letty went through several incarnations in terms of her interests," Bert chuckles. "That's what kept her interesting. We both live in a world of ideas, and neither of us has ever been a shrinking violet about expressing them."

"People have asked us, 'What's your secret?'" says Letty, "and we wouldn't presume to say. Maybe it's luck. We're not so smart that we planned how to do this right." She pauses to reflect, then adds, "But we have figured out a couple of things—don't call them secrets, or rules.

"The first is we don't believe in the saying, 'Never go to sleep angry.' We go to sleep angry. When we wake up, we wake up with a clearer perspective. I don't understand the idea of not going to sleep angry, because it glosses over everything. Besides, guess who it falls on to make nice? The woman. Men don't worry about going to sleep angry. They can usually turn over and go to sleep. Women are the ones who want to talk. I can't stand that. I need to go to sleep. Let it form so we can talk about it later.

"There's one other thing," she continues. "This is something we both tell our children. Don't say the very worst things. You know what would be most hurtful to your partner. Because you know your spouse so well, you've got all the ammunition. But you can't always take the scathing words back. Over time, they form layers, and those layers are corrosive. You can't say, 'Forget I said that. It was said in anger.' Cruelty sticks. I've always practiced this, and Bert has too—not saying the meanest thing we might think of in the heat of the moment."

Bert drapes an arm around her, and she leans close. Anger is the last thing on their minds.

LEONARD AND EVELYN LAUDER

Something Lasting

Forty years ago, Evelyn Lauder married into what would become a cosmetic dynasty and inherited a most imposing mother-in-law. Evelyn was smart, pretty, and self-assured, but she was very young. People whispered that Estee Lauder would be a very hard act to follow.

This was all nonsense, as far as Evelyn was concerned. In the first place, she hated the word *dynasty*, and would have none of it. In the second place, she was deeply in love with Leonard, Estee's eldest son. And in the third place, Evelyn and her mother-in-law bonded immediately. Estee would often say that Evelyn was the daughter she had always longed for.

It also turned out that Evelyn had a natural instinct for the cosmetic business, and she loved the challenge of retail. She had—and continues to have—a genuine interest in people and an embracing warmth that is completely disarming. For most of their marriage, Evelyn and Leonard have been partners in business, parenting, and love. Even now, there is a physical spark between them. They are still crazy about each other after all these years.

It's hard to pick up a magazine, visit an art gallery, or live in New York without encountering some facet of the Lauders' many commitments. Everyone who knows them agrees that they are caring, generous, highly energetic, and interested in the ways they can touch people's lives.

Their apartment features their art collection, an important facet of their lives. Leonard's artistic and

philanthropic passion is collecting—and sharing. "Many collectors want to possess," he says, "but I believe you have to share art, give it, make sure it gets back in the public's hands." To that end, Leonard has given many works of art and generous donations to the Metropolitan Museum of Art, the Museum of Modern Art, and the Whitney Museum, where he is chairman of the board.

As a couple, the Lauders clearly abide by the philosophy that to those whom much has been given, much is expected. They clearly believe they have a responsibility to give back. Evelyn, too, is distinguished most by her generosity—in particular, her tireless work for breast cancer research and state-of-the-art cancer care. She founded the Breast Cancer Research Foundation and serves as its president. She also helped to establish the Evelyn H. Lauder Breast Center at Memorial Sloan-Kettering Cancer Center—a diagnostic and treatment center that is a model for others around the world.

The business of the Lauders may be the surface world of cosmetics, but the Lauders are real-life examples of an opposite quality—that which is lasting. At the top of the list is their enduring love, which they express openly and enthusiastically. Their attraction and affection remain out in the open, as if they were young lovers.

The juxtaposition of the Lauder's forty-year love affair against the ephemeral nature of their business—and, indeed, the world they live in—is a regular topic of conversation. "It's the Kleenex age," says Leonard. "Everything is disposable—ballpoint pens to lipsticks without refills. It's no wonder that people have such an easy time tossing off commitments." He and Evelyn have created in their marriage a balance to the whimsical nature of the products they sell. From the moment so long ago that Leonard blurted out, "You *have* to marry me" to their present status as doting grandparents, Leonard and Evelyn have remained best friends. They talk openly about commitment, and the seriousness with which they take their marriage vows. "It's not just commitment to the good times," Leonard says. "Commitment is the good times, bad times, happy times, sad times, healthy times, ill times, times when you want to crawl into bed and never get up."

Evelyn adds, "It is also a sense of loyalty—always being supportive and never undercutting the other person. Leonard and I have made certain rules and regulations about any disagreements we might have. One of them is that we will never go to bed angry, and will resolve our differences beforehand. I know people say that all the time, but I mean it completely. What I'm talking about, really, is solving problems. Many people in marriages don't know how to begin to address their problems.

They ignore them and let them fester. Or they get angry and defensive. You have to make accommodations in marriage, but that isn't some vague idea. It's real. Sometimes you make accommodations that you don't like. I often tell my children that."

In a sense, Leonard and Evelyn view themselves as a foundation upon which an entire network of relationships are built. When they speak of commitment, it is not just to each other, but also to the people in that network. "When we were married, we made a commitment to each other," Evelyn explains. "When we had children, we made a commitment to stay in the family. We became part of a network. Strong family is an old-fashioned value that seems less treasured today, but it is still the basis of our society. It's what makes us happy."

MATTHEW MALLOW AND ELLEN CHESLER

You, Me, and the World

Aᴄᴄᴏʀᴅɪɴɢ ᴛᴏ ᴇʟʟᴇɴ ᴄʜᴇsʟᴇʀ, the best part of being married to Matt Mallow is what they do *independently* of each other. Don't take that the wrong way. She hastens to explain: "We lead very busy, very autonomous professional lives. Matt is a senior partner at the law firm of Skadden, Arps, Slate, Meager & Flom. He's involved in high-powered corporate deals, and I know little about business. I work for an international foundation as an advisor on reproductive health and rights, and I've written a book about Margaret Sanger and the birth-control movement. Matt always says that he couldn't imagine writing a book."

And what do they share? That's easy: politics. It would surprise no one who knows them to learn that politics brought Matt Mallow and Ellen Chesler together some twenty-seven years ago. They met working on Carol Bellamy's campaign for the office of New York City Council president.

"We were out one night tearing down posters," Matt says.

"Putting up posters," Ellen corrects him. "We were putting up posters, not tearing them down."

"I took your breath away," Matt embellishes.

"You had such deep, thick black hair. You were very handsome," she concedes. "But we were both involved with other people at the time. Then, when Carol won, the mayor invited everyone to an open house at Gracie Mansion. Carol had no family except us. We were the family."

"So," Matt concludes, "we drank a lot of the City of New York's liquor, and we've been together ever since."

The point, made in a roundabout way, is that although the two have very different career focuses, their continuing commonality is what Ellen calls "a deep, abiding interest in the world. It's a relationship that's not only about ourselves, but about others as well."

Matt and Ellen are part of an enduring tradition of political activism. Now that they have acquired the means, they are instrumental in fund-raising and promoting candidates. Ellen is part of an expanding circle of influence around women in politics, and she brings substantial expertise on women's health issues to the table.

Although Matt and Ellen are very much the products of their generation, and the trade-offs they've made in work and marriage reflect that, they are also the products of strong, committed families on both sides. "I like to say that we each found our parents," says Matt. "I don't mean that literally, of course, but our parents were overwhelmingly strong models for a good marriage. And my mother was a very strong personality, so she was a different kind of role model. I can't imagine that I could ever have married a woman who did not have a strong, independent personality. I hope our children feel we are strong role models for them."

Ellen nods. "I know what you mean. So many young people don't have any sense of what it means to be committed. There's a young woman in my office at the foundation, and she and her husband recently split up. She told me, 'We just decided it wasn't right.' I said, 'What do you mean it wasn't right?' I didn't get the concept. There are always some things that are out of kilter. But I think it's also important to realize—and I'm putting on my historian's hat here—that perhaps young people have different expectations because their world is so different. Matt and I grew up in a world where men were still expected to be breadwinners. Kids today have virtually no sense of that. They've grown up in a world that is gender neutral in many respects. They are so completely equal. Look at how much has changed since our parents' generation, when women tended to put all their eggs in the love and family basket. My biggest hope for our children is that they find work that engages them, and also love. Love and work. Like we have."

There's more to be said. But a political dinner awaits.

MARY HIGGINS CLARK AND JOHN CONHEENEY

Young Lovers in Heart and Mind

Mary Higgins Clark writes about ordinary people going about their daily lives, not looking for trouble—or romance, for that matter. But somehow it finds *them*, sneaking up and catching them when they least expect it. John Conheeney, her husband of four years, could well be a character in one of her books.

John was quietly going about his days, trying to put his life together after the death of his wife of forty years. With four adult children and nine grandchildren, he was not alone, and the idea of remarrying never entered his mind. One of his daughters and her family moved into his house in Ridgewood, New Jersey. He bought a dog, and took up golf again. He was content.

A retired Merrill Lynch Futures CEO, John was well liked and respected in his field. When he was invited to join the board of the New York Mercantile Exchange, he willingly took on the challenge.

At the Mercantile Exchange, John became friendly with a young assistant named Patty Clark. One day, she asked him about his wife. When he told her that he was a widower, her Irish eyes sparkled. "What a coincidence," she exclaimed. "My mother is a widow!"

John didn't know it, but his life was about to change. He had no idea that Patty's mother was the famous writer Mary Higgins Clark, whose place in the popular culture was well established. Mary was glamorous, beautiful, talented, and exciting. Her reality seemed far removed from John's now

quiet life. Patty would often talk about her mother, mentioning that she was off to Paris, or returning from London, or receiving yet another in her long list of honorary doctorates. When John found out who Patty's mother was, he was surprised—and a bit unnerved, since Patty seemed to be heading toward a matchmaking scenario.

"I was out of practice dating," John says. "In fact, I'd never really dated much at all. I was married very young, and my first wife was pretty much the first woman I'd ever been out with. After her death, I would occasionally be invited to dinner as the partner of an unattached woman, and I hated it. I felt inadequate to handle those situations. When Patty invited me to a party at her mother's house to celebrate St. Patrick's Day and commemorate her newest book, I started planning my exit before I even arrived."

John remembers that he had expected there might be ten or twelve people other guests, but when he had to park two streets away he realized that Mary loves to throw a party. There were nearly one hundred people in the house.

"No one heard the doorbell," he explains, "so I opened the door, walked in, and saw Mary across the room. I can honestly say that sparks flew."

He shakes his head ruefully. "Patty's very straightforward and no nonsense. When I left three hours later, she kind of pointed her thumb over her shoulder toward her mother, and asked, 'What do you think?' I said, 'I think your mother's lovely.' And she was. She was the most beautiful woman in the room, and so full of life. Patty didn't mince words. 'Aren't you gonna ask for a date?'"

Mary, who has been listening quietly to John's account, raises her eyebrows in mock horror, and says, "I almost *fainted* when she said that."

She's not entirely convincing. There's a shrewd glimmer in her eye, and eventually the truth comes out. She wasn't all that surprised. In fact, John was set up.

"Well, you see," Mary explains, "Patty had already called and said, 'Have I got a hunk for you.' Those were her first words. Then, 'He's so well respected in the financial world. He's so nice. He's a widower. He's good looking. He's not going around with anyone—I checked.' Well, the poor soul didn't have a chance."

John nods helplessly. Women! He doesn't really seem to mind.

"Patty's a good girl." Mary beams with satisfaction.

When John says that he screwed up his courage to make the first call, one can sympathize. Whether you're sixteen or sixty, that call is made with your heart in your throat, and John was about forty-three years out of practice. He was relieved when Mary accepted his invitation to dinner, and he was totally taken with her as she sat across the table from him. She wasn't at all the remote star he expected. Rather, she was an intelligent, interesting, warm-hearted woman. John was touched when Mary opened up to him and talked about the trials of her early life. It put her later success in perspective. "I admired the way she persevered," he says. "Growing up poor, her father dying when she was ten, then having her husband die and leave her with five children. She didn't give up or become bitter."

Falling in love and getting married seemed like the most natural thing in the world for John and Mary. They're enjoying the special advantages of being married later in life, with the responsibilities of raising children and building careers behind them. "It's wonderful," Mary raves. "It's fun. We have so much fun together. And let's face it, especially later in life, if you're a woman alone, even a celebrity, you get left behind a lot. We're lucky to have each other."

John has an easy answer when asked what he likes best about being married again later in life. "The best thing about being married to Mary is I love her. And at my late stage in life I never thought that was going to happen. So it has and I'm very grateful for it. We have a lot of fun together." He winks at Mary. "It's a nice bonus that she makes oatmeal the way my mother did. I hadn't had any in forty years. It's a four-star marriage. But there's only one star in it."

JOHN AND JACKIE LEO

<div align="center">∞</div>

It Takes Teamwork

Jᴀᴄᴋɪᴇ ʟᴇᴏ ʙᴏᴜɴᴅs into the room, flushed and breathless from a game of tennis. As editor-in-chief of Interactive Services for the Meredith Publishing Group, she lives life on the run. She is an attractive, dynamic woman, with dark, intelligent eyes and a lively personality. Her husband, John Leo, a long-time columnist for *U.S. News and World Report*, is more laconic, laid back, and reflective. They can at least partially escape the media drumbeat of Manhattan by spending time at their Sag Harbor, Long Island, home.

Although their business lives have always converged—Jackie has been an editor at *Modern Bride*, the editor of *Family Circle*, and the founder of *Child* magazine—they didn't meet through business, but on the baseball diamond. "We began our sporting life together in 1976," Jackie jokes, "at the first-ever Sag Harbor softball game." The games evolved into a proud tradition over the years, and John and Jackie went on to create a tradition of their own.

They were well matched on the ball field, but their lives to that point were much different. John was eleven years older, and had two children by a previous marriage. Eleven years is not that great an age gap, but at the time, it placed John and Jackie in radically different cultural environments. As Jackie candidly explains, "I'm very much a boomer by comparison to John. I was part of the culture of sex, drugs, and rock and roll." In that respect, Jackie notes, an early first marriage was more about freedom than commitment. "We got married, we lived abroad, we played. When reality set in, and we

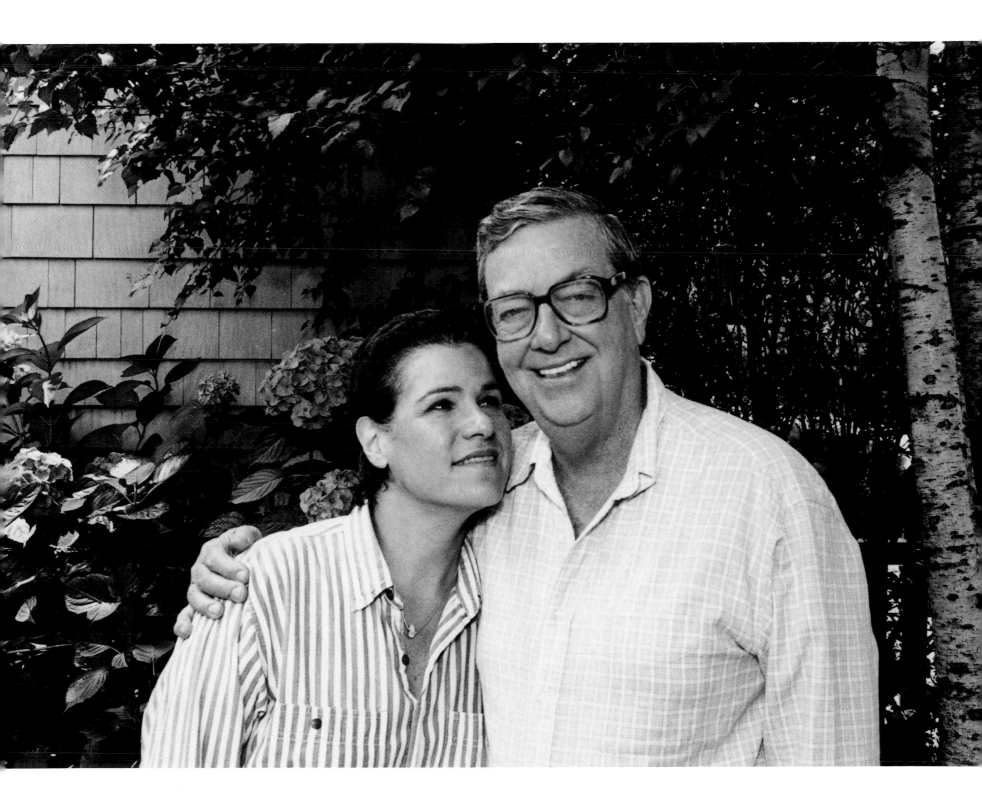

had to settle down, it didn't work anymore. When I met John, I remember thinking to myself, now you can have a grown-up for a partner."

"We were both hurt in our first marriages," says John. "What was different was the honesty. It was all within the framework of candor. That was new."

Jackie calls it "unbridled honesty. You have to have a level of trust to allow so much honesty in a relationship. John and I have always had that."

Often, John provided a steadying force as the couple built a life together. For one thing, having had two children, he was experienced in the practicalities of child raising. When their daughter Alex was born, four and a half years after they married, he pitched in with an easy, comfortable manner. This was especially important because Jackie had a busy, highly pressured career. To make family work, they had to be a team—not just in family, but in work as well. They had separate careers, equally successful, but they were not traveling in separate orbits. John credits Jackie with being able to inject fresh insight into his writing when he's stuck on something. Jackie gives John credit for helping her become a top-notch journalist. "He helped me develop the confidence to dig deeper," she says. "He knows how to probe, to get to the bottom of things."

They also made a deal from the start to support each other's best interests in work. "We agreed that either of us could walk away from any job that wasn't right for us, and the other one would pick up the slack," Jackie explains. "Having that kind of support is tremendously reassuring."

The biggest struggle is time. There's not enough of it. It can be overwhelming to be in the information business. "There is always a pile of magazines that haven't been read," says John. "Or newspapers. Or books your friends have written that you haven't read. Or e-mails. It's endless."

Jackie adds, "And our biggest problem is not making enough time for ourselves. Sometimes it feels as if we have an e-mail relationship."

Meanwhile, they have a teenager to raise. Alex is seventeen now, and like all teenagers, she's busy creating her own identity and pushing at her limits. It is in this arena that the couple's generational differences come to the surface.

"I do have a different view of teenagers," Jackie says. "Part of it is that I remember being a teenager."

"I never was one," John says solemnly.

Jackie laughs. "True. He skipped over that period. He was a very earnest young man. My genera-

tion, though, we pushed the cultural envelope, so I can relate to some of what Alex is experiencing."

"She's a dear, wonderful child," John says affectionately. "We adore her. But I admit it, I'm aghast at the exposure teenagers have today. They learn so quickly, they know so much about the world. They're rearranging the furniture in their minds and their hormones at the same time."

What John and Jackie both acknowledge proudly, is that, in all the important ways, Alex is a product of her home environment. "She is intensely loyal and generous," Jackie says. "She loves her family. She has many close friendships—really, an ability for extraordinary commitment to the people she cares about. That's what she takes away from growing up with us. For me, that's the best evidence that our marriage is working."

TIM AND NINA ZAGAT

The Pleasure of Your Company

T IM AND NINA ZAGAT had an appetite for food—but not just for food. For travel—but not just for travel. For new experiences, and out-of-the-way treasures, and making friends, and being together. So what were these two young lawyers doing, climbing the career ladders at conservative Wall Street law firms?

Tim and Nina Zagat (pronounced, Tim emphasizes, "Zag*at*, like Cat in the Hat") met in 1963 in a contracts class at Yale Law School. It was a small class, only ten students, and they started studying together. Tim discovered that Nina was the first person he'd ever had fun studying with. It wasn't dinner in Paris, but still . . .

"I enjoyed being with Nina regardless of what we were doing," he says. "It didn't have to be going out and having so-called 'fun.' We could be in class, or walking together, or driving, or shopping, almost anything. And she was a great cook."

For her part, Nina says, "With Tim, I didn't have to perform or think of something brilliant to say. Also, I thought he was fun and interesting."

They never planned on going into business together, and when you look at the couple today, in the midst of the bustling offices of Zagat Survey, they don't look the least bit like the founders of a multimillion-dollar publishing empire—one that was just infused with an additional $31 million from

major investors. Tim is a casual, chatty, feet-on-the-desk kind of guy, who loves to talk about food, travel, and the people they've met. Nina is more reserved—almost shy—but the operative word for both of them is *fun*. They are known to be generous philanthropists, unpretentious dinner companions, and very astute in their business dealings. Nina is the financial whiz, while Tim handles the creative side. Whatever their secret, it works.

In many respects, the way Tim and Nina started the company says a lot about the kind of people they are. They didn't even think of it as a company, really—just a tremendously fun, somewhat costly hobby. The inspiration came after Tim's law firm sent him to Paris for two years. Nina's firm agreed to send her to France too, and they settled into an apartment on the Left Bank. Those years, says Tim, changed their attitude about life and about family.

"The French give a much higher priority to the family being together," Tim says. "They get together for a full month's vacation in August, for Christmas, a weekend, to celebrate spring. Any excuse. At first I thought, 'These people are really lazy,' because they weren't workaholics like Americans. But the more I thought about it, the more I realized that they just valued family life more. We came away from our time in Paris appreciating that other things were important besides how many hours you spent in the law library."

They had also discovered the wonders of fine food. Back in New York, they organized a group of friends for monthly dinners at great restaurants, or at one of their homes. These were gourmet feasts, featuring many dishes and several different wines. At one dinner, they were complaining about how unreliable restaurant critics were, and the idea of a restaurant survey was born. Tim decided to create a questionnaire and poll their friends, then distribute the results. The first survey, produced in 1979, was a photocopied sheet. It polled one hundred friends and listed seventy-five restaurants. For the next four years, they continued the survey as a hobby, and only began to charge for it in order to defray costs. By then, it was a rapidly growing word-of-mouth hit, and the Zagats were more astonished than anyone when it took off. Within three years, they were selling 100,000 copies of the *Zagat Survey*.

Still, their publishing endeavor has always been more about fun than money, and their thirty-four-year marriage has centered around the pleasure they take in each other's company. When they are asked if so much togetherness doesn't get to be a strain, they seem baffled by the question, as if they can't comprehend how this could be a problem.

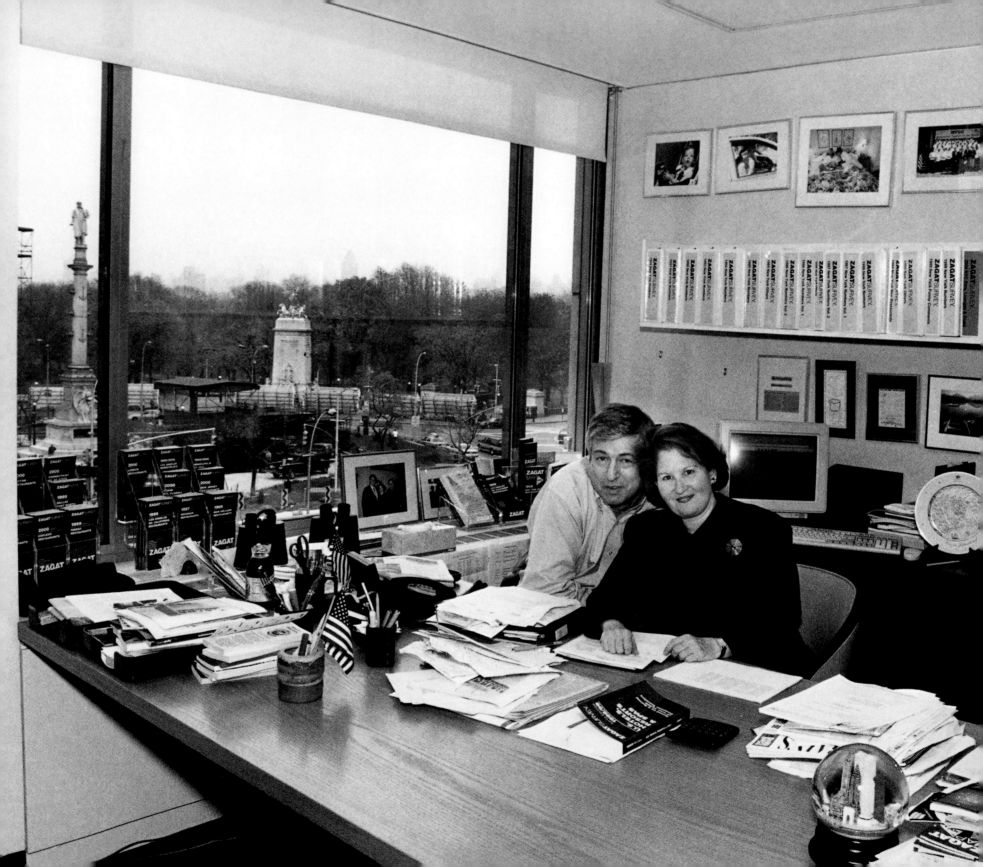

"Our relationship is much richer this way," says Nina.

"We're very, very good friends. We like each other." Tim shrugs. "Even work. What's so bad? We are constantly meeting with interesting people because of what we do relating to food and travel. Lots and lots of people love our work. Last night we had dinner with one of the senior editors of *The New York Times* because we're doing a special event that the *Times* is covering. Wonderful food. Fascinating conversation. You could call that *work*, or you could call that *pleasure*. For us, it's pleasure."

They've raised their two sons, one of whom works for the company, with the same perspective. "Very simply, we taught them if you give a lot, you get a lot," says Tim. "Seeing them come through and become really great people as grown-ups is one of the most satisfying things imaginable."

Nina glances pointedly at her watch. "I've got to go," she says apologetically. Tim leaps up from his desk. "So sorry to rush, but we have to work tonight." He feigns regret. "Dinner at eight, for twelve of our best European survey respondents." He winks. "Le Bernardin. What a life."

DAVID AND HELEN GURLEY BROWN

Eternal Flames

Dᴀᴠɪᴅ ᴀɴᴅ ʜᴇʟᴇɴ ɢᴜʀʟᴇʏ ʙʀᴏᴡɴ live their lives entwined in a contradiction. They are the very picture of a thoroughly modern couple. Yet they are also completely old-fashioned.

The old-fashioned part of the equation is easily measured. After forty-one years of marriage, they remain a loving and loyal twosome. They dote on each other, forming a mutual admiration society.

The modern element of this contradictory measurement is more complicated. Even as Helen zealously guards her own wonderful marriage, she just as ardently urges other women to have affairs or get divorced, especially if the flames of romance have died down. If the spark is no longer there, Helen believes it's time to move on. "Marriage isn't an *institution*," she says. "It's an *adventure*. When I realized how I felt about David, I remember thinking, oh, this is something I want to try. Having a fabulous life adventure with one other person. I can't understand people who are afraid of getting married. I say, 'Go for it!'"

Helen's office at the Hearst Corporation is a triumph of decorative will over the realities of time and space. When you first enter, you think you may have stumbled into a sitting room or even a bedroom, were it not for the desk piled high with papers and the hulking manual typewriter—another nod to old-fashioned whimsy. The floor is carpeted in leopard print. The walls are covered with rose-colored silk, the window and sofa are draped in bold floral splashes of pink and yellow. Helen and

David sit side by side on colorfully upholstered chairs of different heights. Helen's chair is a diminutive edition of David's full-sized version. It suits her slender, fine-boned frame perfectly. She and David seem a far more youthful couple than their years would suggest.

David is tall and handsome, a brilliant film producer, whose credits include *Jaws*, *The Sting*, and *A Few Good Men*, among many others. He has a quick wit, a natural charm, and a devilish smile that creases his perfectly trimmed white mustache. Helen is the brains behind *Cosmopolitan* magazine, and the soul of girlish delight. She is vital, funny, and her opinions never fail to surprise—and sometimes shock. It's hard to imagine that this woman once coined the term *mouseburger* to describe herself.

There are few secrets in this marriage. Millions read Helen's account of their meeting in *Sex and the Single Girl*, and she's never been shy about using her own experiences to better define that complex creature known as the "Cosmo girl." This year, at seventy-nine, she adds tantalizing new details in her book, *I'm Wild Again: Snippets from My Life and a Few Brazen Thoughts* (St. Martin's Press, 2000).

When she met David, already making a name for himself as a Hollywood producer, Helen thought he was tremendously glamorous. For his part, David had never met anyone quite like Helen. "She was the first woman I ever knew who paid cash for a Mercedes," he jokes. In fact, she was much more—an absolute enigma in the culture of the late 1950s. Unabashedly sexual and ambitious, she could be soft as silk or hard as nails. Still single at thirty-seven, she knew what she liked, and she set out to get it—or, in this case, *him*.

"I wanted David very much," she says, favoring her husband with an adoring glance. "I did everything I could to woo him and win him."

Was he hard to win? "Very," David replies. "I had two divorces behind me, and I was single for the first time in years. I didn't see why we couldn't just continue on as we were. We weren't living together, of course. One didn't then."

"But I moved to an apartment nearby," Helen interjects. "It was one of my strategies for getting David to like me."

When David resisted marriage, Helen took action, as she has since advised all women to do—as long as they really mean it. "I went on strike," she says. "I said, 'If you won't marry me, I'm leaving.' Then I disappeared."

It was a gutsy move, and it worked. David Brown had very much liked what he'd had. Now he

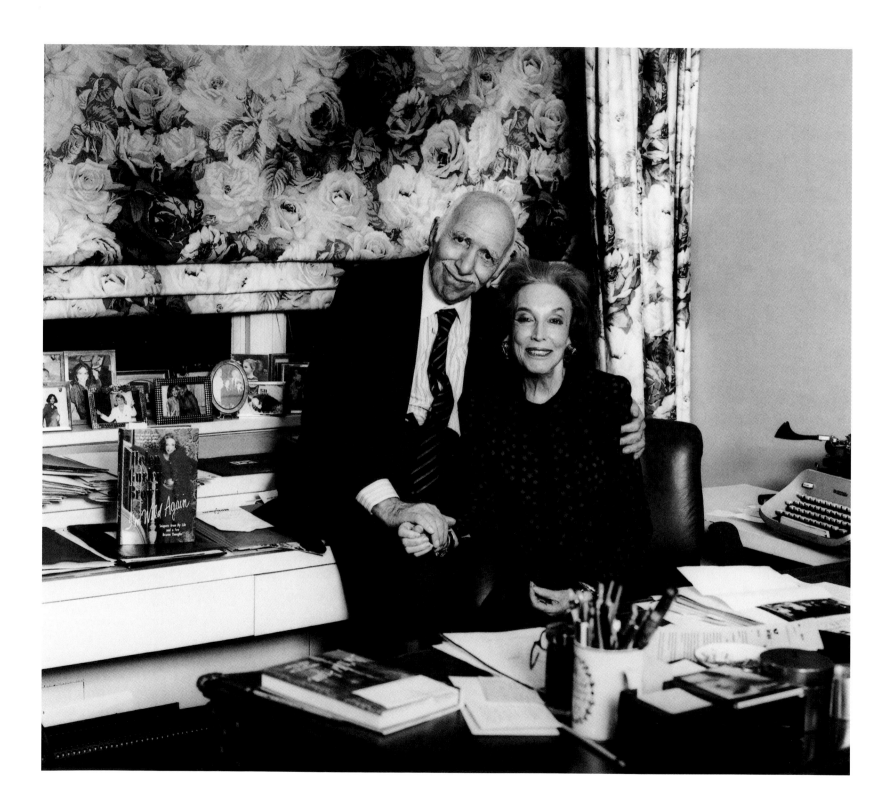

was suddenly without her—Helen had left him. He quickly realized what he was missing, and his resistance was laid to rest. They were soon married.

It was David who convinced Helen that she should write a book about her experiences. The result, *Sex and the Single Girl*, published in 1962, was an instant hit. It was also David who determined that Helen's message was perfectly suited for a magazine format. *Cosmopolitan* was modeled on Helen's philosophy that a young woman doesn't have to be rich, beautiful, or brilliant in order to be appealing and get what she wants out of life. She needs only desire, self-confidence, and a few carefully executed strategies. Those strategies and that philosophy represented a cultural sea change for many women. The phrase "Cosmo girl" came to define a certain kind of woman for generations across the globe.

Helen was the editor-in-chief of *Cosmopolitan* for thirty-one years before stepping down in 1997. She now oversees the magazine's forty international editions and hasn't slowed down one bit. She can be found working in her office well after seven o'clock most evenings. Now in his eighties, David matches his wife's pace with a grueling work and travel schedule of his own. Their work—even the absences forced on them by clashing schedules—only seem to fuel the flames of their devotion. Their favorite thing is to be together, alone, cooking dinner, talking shop at the end of another long day.

When Helen reflects on the wonders of her very special marriage, she gives credit to David—"the freedom he has allowed me to do my work and become a success in my own right, and the safety I feel in his love." She sits up straight on her tiny chair, and with girlish enthusiasm rising in her voice, says, "What more wonderful gift could a man give a woman than this opportunity? David gave me the idea for my first book. He encouraged me to go for it with the magazine. What could be more *yummy* than a man who will do that?"

ALLAN AND TAMARA HOUSTON

Covenant to Keep

Allan and tamara houston certainly have earned a place in a book about commitment, but it isn't because of the longevity of their union, or the acquired wisdom that comes with age. It's because of the difference they make, the highly visible example they set for others.

People the Houstons' age have been cynically branded as belonging to "Generation X." The term is meant to conjure up the image of a rootless, unformed, directionless society of a certain age, suffering from a chronic case of immaturity—the antithesis of people who believe in commitment.

Now add the glossy, overexposed world of professional basketball to the mix. Professional sports of all kinds, and basketball in particular, is a notoriously tough world in which to maintain the demeanor of a serious person, a thoughtful husband and father with a quiet home life. The increasingly fatal combination of money and adulation creates a slippery ground on which to keep one's balance, much less build a stable life. Yet that's just what Allan and Tamara Houston have managed to do.

Allan Houston, a lithe and muscular All-Pro guard playing for the New York Knicks in the Eastern Conference of the National Basketball Association, has a reputation for being a good guy—a solid, decent man unaffected by the heat of the sports environment. He has an open, friendly smile. At 6'6" tall, Allan towers over his wife Tamara, but she has no problem holding her own. An intelligent woman

with a direct manner and very strong opinions, she seems to be the anchor who holds their relationship in place.

Surrounded as they are by opulence and opportunity that's arrived at such a young age, it's a wonder that Allan and Tamara have managed to remain so grounded. First and foremost, they grew up with very positive role models. Strong family ties beget strong family ties.

"Our great-grandparents stayed together," Tamara says. "Our grandparents stayed together. Our parents stayed together. You get married, and that's what you do."

Allan nods, "The way both our parents viewed their marriages was, 'We're together, and we don't look past that. No matter what happens.' And that's what we both saw when we were growing up."

There's another crucial element that Allan and Tamara don't hesitate to talk about—their faith. "The church has always been big in our families," Tamara says. "And we've rededicated ourselves to that."

"We both put God first," Allan says simply. "To me, that's a very important part of our marriage. When you get married, you make a covenant with God. I think the reason a lot of marriages aren't successful is because the couples don't bring God in as a primary part of those relationships right from the start."

As they talk, Tamara bounces their beautiful baby daughter on her lap. She's like a little doll—dark, expressive eyes, a mischievous smile, and a crown of curly black hair. When they speak of their daughter's future, the Houstons believe that they can become the role models for her, just as their parents were for them.

"We're going to try to teach our daughter what we were taught," Tamara says. "Respect yourself, respect others. Make a contribution."

"I want her to learn that the way you express your character and integrity every day speaks volumes, more than you can ever say," Allan adds. "So we try to live our lives as best we can every day, and remember that we're examples for her as she grows. Someday she'll be able to say to her friends, 'These are my parents. They're together.'"

"And they loved each other," Tamara adds.

"They loved each other." Allan grins. He stretches, and they smile at each other. Tamara hands their daughter to Allan, and he takes her gently in his hands, cooing at her as he draws her near. They seem content.

SUSAN ISAACS AND
ELKAN ABRAMOWITZ

⸺⸱⸺

Positions of Compromise

IN THE STORY, Susan Isaacs and Elkan Abramowitz were the innocent victims of manipulation—set up by meddling family members. She was a vivacious young urbanite with a saucy, independent manner—an assistant editor at *Seventeen* magazine. He was a young trial lawyer, handsome and easygoing, with a mop of curly hair and a disarming grin. To the delight of their families, they clicked.

Add murder, mayhem, and all the furies, and they could be the lead characters in a Susan Isaacs novel. But it didn't happen that way. Susan and Elkan have always had plenty of the *good* heat (passion) and very little of the *bad* heat (conflict). They had their differences—among them that he was raised in a religious Jewish family, and she was raised in a nonobservant Jewish family—but they tended to take the compromising positions on these issues rather than conflicting ones.

However, this ability to compromise in no way implied submission. "This was 1968, remember," Elkan says. "There was still an attitude of inequality. There was unity, but it was really unity to the man's position. I didn't want a woman who was just going to say, 'You're right, you're right, you're right.' Many men found that kind of behavior reassuring, but it made me uncomfortable. In fact, the women I dated before I met Susan tended to be that way. And the more deferential they were, the less interested I was. I really wanted a partner that would stand up for herself, someone who knew what she wanted, and would say what she wanted."

"Well, you got that." Susan laughs. "Besides, we had a lot in common—like politics. Not just where we stood on the issues, but the intensity of our interest. We wallowed in Watergate together, for example."

Fortunately, they agreed on the important things. When it was time to start a family, they decided to move out of the city, but their specifications were precise. "First of all," Susan says, "we believed in public schools, so we wanted good public schools. And the neighborhood had to be mixed, economically and ethnically. And it had to be no more than an hour commute from the city." They settled on Port Washington, a suburb on Long Island, where they live to this day. There they raised their two children, Andrew and Elizabeth, in a traditional conservative Jewish household. Elkan became a successful trial lawyer, and Susan settled into her life as a typical suburban wife and mother—with a slight difference.

As soon as Elizabeth, their youngest, was in nursery school, Susan started to write a novel. She insists it was just an urge, not anything she'd ever planned. "This character came to me," she recalls. "A suburban housewife who becomes a detective when her dentist gets murdered." *Compromising Positions* became an overnight best-seller, and later a movie starring Susan Sarandon and Raul Julia. It was funny, sexy, and intellectually provocative, with a gutsy heroine. In other words, the heroine was like Susan herself. Readers warmed to the woman as much as to the story. She followed that initial success with a string of novels. Each one has featured a strong, interesting woman, and all have been instant best-sellers.

Susan's newfound success did not rock their world because they'd established a solid foundation from the very beginning of their marriage. Elkan was thrilled, not threatened. "It didn't take anything away from me," he says. "There was a time when I'd get asked if she made more money than I did—as if that would be a terrible shame for me. My career was on track, it didn't bother me. In fact, what seems to make a lot of marriages unstable is when one partner has a meaningful career and the other doesn't. We both had meaningful careers." Not that Elkan hasn't been highly successful himself. A partner at the firm Morvillo, Abramowitz, Grand, Iason, and Silverberg, he is considered one of the leading trial attorneys in New York. Most recently, he represented Woody Allen in his highly publicized custody battle with Mia Farrow.

Success has been terrific, but what holds them together is the family. Money doesn't make it easier

to cope with a beloved parent's death. Success didn't make it easier for Susan to face her mother's slow deterioration from Alzheimer's. Being a family *did* help. "I'm an only child," Susan says. "When my mother had Alzheimer's, I would say to Elkan, 'In some ways, I wish I had a brother or sister who I could really be angry at for not doing their job.' On the other hand, Elkan was more like my mother's son than a son-in-law. He pitched in and shared the burden with me. And Elkan's dad was a wonderful man, and a great character. He lived to be ninety-three, and when he died, I mourned him as if he were my own father. So you see, we're all one family."

Elkan and Susan have provided the spark for that family—the enduring passion and delight that has followed them from youth to midlife. Maybe their daughter, Elizabeth, said it best. Recently, while on her honeymoon in France, she called them. "You'd love it here," she raved. "This is a place where lovers go."

Susan beams and wraps her arms around Elkan. "She thinks of us as lovers. Isn't that a wonderful thing?"

PETER AND LENI MAY

Beyond April Love

Peter and leni may met when they were fifteen and sophomores in high school in Woodmere, New York. Leni's best friend had a date to go to a party with Peter, but she got sick and suggested he take Leni.

"We danced all night to Pat Boone singing 'April Love,'" Leni says with a grimace. "Corny. The following Monday, Peter came up to me and handed me a brown paper bag. Inside was the 45 record of 'April Love.'" That was the beginning.

It is a rare thing in this day and age to meet a couple who have been together since high school and are each other's one and only great love. Peter and Leni dated throughout high school. When they graduated, Peter went to the University of Chicago, and Leni went to college in New Jersey. They maintained their relationship primarily by telephone. But after two years, Leni called Peter. "I don't think absence makes the heart grow fonder," she said. They decided she would join him in Chicago.

"Those were the days when you didn't sleep together," Leni says. "I stayed in the dorm. We got pinned right away, and we were married when Peter graduated. Then we could sleep together."

Even today, after a lifetime together, and thirty-five years of marriage, Peter and Leni can acknowledge that marrying so young had consequences. For one thing, they had to grow up fast. Part of the

struggle of those early years, however, had more to do with forces in society than with their own commitment. They are refreshingly frank about what happened next.

"This was the Vietnam era, and I didn't want to go," Peter says. "I was very anxious to get on track in my career. "But after we had been married a year, President Johnson canceled the marriage deferment. You had to have a child to get a deferment. I looked at Leni and said, 'I've got a job starting in the fall. Let's have a baby.' She said—"

"Absolutely not," Leni finishes. "We'd talked about this, and decided we wouldn't start a family for five years. We'd been married so young. We needed the time. Besides, I had a career too. I was teaching, and I wasn't ready to give it up. I tried to convince him to go into the reserves, as my brother and a lot of our friends had. But he was adamant, and I caved in. We had our first child two years into the marriage."

And so the stage was set. They moved back to New York, and Leni's job became raising their child. A second child followed after four years. Meanwhile, Peter was singlemindedly pursuing his business career, and putting in long hours.

Peter is brutally honest about his insensitivity during those years. "Leni made all the compromises," he says. "I did what I wanted to do, and made decisions according to how I wanted to advance my career. There wasn't a lot of obvious tension between us, but I realized later that there was great subliminal anger on Leni's part because she had been forced into this role."

The Mays' story will strike a familiar chord with many couples. They weren't unhappy—far from it. They adored their children. They had fun together. They had a strong attraction to each other, physically and emotionally. As Peter's investment career flourished, they became very comfortable financially. But lingering beneath the surface was Leni's fear that she had missed an opportunity of her own. The children were getting older; they needed her less and less. She was heading toward a crisis.

"Maybe I should have gone back to work then," Leni says. "I don't know. But I was in a funk."

"That was the most difficult period," Peter says. "I was still very preoccupied with my career, doing very well, and getting a fair amount of stature. This was very good for me and my ego, but it probably put more pressure on Leni in terms of her self-image."

While Peter's attention was on his work, Leni was growing increasingly depressed and unhappy. Her children no longer needed her, her husband was engaged with his career, and she felt completely

inadequate. She couldn't even remember the young girl she had once been, with all the plans and aspirations.

Peter noticed the change in his wife with alarm. "I didn't know what was going on," he says. "She wouldn't get help."

"He was scared," Leni says quietly. "He wanted everything to work out, to be good between us, as it always had been. So did I, but neither of us knew how."

So they had to get down to basics and talk things through, even though it was painful. "It sounds trite," observes Leni, "but if I were going to make a list of the most important elements for a good marriage, I would put communication at the top of the list. We had always talked things through, and as soon as we stopped doing that, we began to drift apart."

Today, Peter and Leni have the confident, satisfied air of partners who have come through difficult times and emerged more secure in their commitment than ever. They are the living testimony that love can last a lifetime.

Peter smiles broadly when he says, "I'm almost reluctant to say how happy I am, and how wonderful things are. I don't want to jinx it. But we're at a time of our lives when things couldn't be better."

Leni returns his smile. "Peter is the best person in the world."

"We say that about each other all the time," Peter adds. "And Leni has become very successful. Not in a job per se, but in numerous other ways. She's the leader of a very large group of people who always look to her for advice or comfort or stability. She has also played a major role in my success. We're a team. People never think of us as Peter May and his wife. They always think of us as Leni and Peter May—a couple."

JEFFREY AND MYRNA BLYTH

Endless Fascination

"JEFFREY WAS FASCINATING," Myrna Blyth says, recalling the dashing foreign correspondent she met in 1959 and married in 1962. "He was the most interesting person I had ever met. He had entered Havana with Castro. He had been in Hungary during the revolution. He had been in Suez. And when we married, he covered the Kennedy assassination. He was standing behind Oswald when Oswald was shot. He inhabited a different world than I had grown up with—a much wider world."

Jeffrey, a British journalist working for the *London Daily Mail*, was equally taken with the young New York writer. He had never really dated an American woman, and he liked her spark, her intelligence, and her independence.

Jeffrey was older, and his cultural foundation was quite a bit different than Myrna's, but in the important ways, they were compatible. Both were a little ahead of their time. With the idea of feminism barely a whisper in the public consciousness, they never for a minute considered that Myrna would not have a profession of her own. They waited to have children until they were both ready, and Myrna continued to pursue a career while their two sons were growing up.

It has been quite a career. Myrna is widely acclaimed for the contribution she has made to women's publishing, most notably in her reign as editor-in-chief of *Ladies Home Journal*. Recently, she

introduced *More*, a lively spinoff for mature women. A great deal of her success can be credited to an unfailing instinct for what women want and need. Early on, she realized that women share many fundamental concerns, even when their lifestyles differ. To this day, she maintains a firm belief that marriage, family, and professional fulfillment can coexist happily in women's lives.

Myrna has also lived through many changes in the ways that Americans view marriage and morality. "During the Clinton scandal, we published a poll in *Ladies Home Journal*," she says. "This was in September 1998. Forty-six percent of women said they would forgive their husbands if they were unfaithful. Seven years ago, only twelve percent said they would forgive unfaithful husbands. I think they're saying that they'll work harder to keep the marriage together."

Jeffrey and Myrna are warm, engaging people, who can show flashes of acerbic wit. Their apartment on Manhattan's Upper West Side is comfortably furnished and welcoming, with spectacular views to the south and west. It is a place they can relax and unwind from careers that involve long days and frequent travel. When they're not working, they are usually together, enjoying the easy compatibility that has developed over many years.

"We read, or go to movies or the theater," Jeffrey says. "We like the same things. We have wonderful times traveling. I've seen just about every place in the world, and I want Myrna to have the experience, too."

"I would say one of the issues in a long-term marriage is keeping one's individuality, while being a couple," Myrna says thoughtfully. "But we've been fortunate. Our careers have given each of us enough of an individual identity that we can really be together at home."

Their anchor through the years has been their children. Jeffrey has some regrets. "I traveled so much, I didn't spend the time with them I would have liked to," he says. "Myrna was with them. . . ."

"It is kind of a shame, in retrospect," Myrna responds, but she adds, "as much as Jeffrey says now that he didn't spend much time with them, in truth we spent every weekend together. We went to the country as a family. We ate our meals together. We watched television together. We sat in the car reciting multiplication tables. We were involved in their lives, and they knew it."

Jeffrey nods. "Family was important."

"Absolutely," Myrna continues. "I think having children is crucial. When you're a couple, going through good times and bad, the children are there too, and you're all part of one family. You might

be angry at each other about this or that, but it's just an incident, one part of the whole picture. We had enough, whether it was the children or work, to feel fulfilled. Don't you think so, Jeffrey?"

Jeffrey nods and laughs. "If we had a fight, it was just a fight. I can't think of a time that one lasted more than twenty-four hours. You know the saying, 'You can say anything you like to each other, if you end it with *dear.*'"

Myrna joins him in laughter. "Yes, it's like that joke—'I love you, I hate you, let's get divorced— oh, gee, we promised we'd go out to dinner with the kids.' In other words, nothing was ever very serious. It was like, 'Should we get a divorce, or should we buy the Wedgewood china?' We bought the Wedgewood."

ELLIS AND GINNY ROLETT

Loyal and True

The IMMEDIATE IMPRESSION one gets upon meeting Ellis and Ginny Rolett is that this couple is the salt of the earth. After forty-four years of marriage, they are settled into a visible compatibility. They don't consider themselves particularly remarkable, as couples go, and it is this quality that is most appealing. In many respects, Ellis and Ginny are the "every couple" of married life. They represent the millions of couples who, without any fanfare, go about living their covenants in the ordinary ebb and flow of life. It's not that they haven't had their share of problems, but they've come through them by way of a tenacious will to make things work.

The early years of their marriage were unsettled. Ellis, now a cardiologist on the faculty at Dartmouth Medical School, was just beginning his internship when they got married. In the first eight years, they moved eight times, including an Air Force stint in London, England. Their first son was born nine months after the wedding, a second followed soon after. They were so busy that they didn't realize how busy they were. This can be a dangerous point in a marriage, when the press of life pulls people in separate directions. The Roletts were living in Lexington, Massachusetts, while Ellis was doing fellowships at Massachusetts General Hospital and Peter Bent Brigham Hospital.

"Ellis was working very hard, and I was taking care of the kids," Ginny recalls. "We were very comfortable and happy, but Ellis just wasn't around much. One Saturday, Ellis was home, and he offered

to stay with the kids so I could run out and do some errands. Barry was about eighteen months old at the time. When I started to walk out the door, Barry's mouth turned down and he started to cry, because he didn't know the strange baby-sitter."

It was a moment of truth. "I didn't want to be a stranger to my children," Ellis says, "so we decided to look for a setting that would give me more time with my family." They settled on Chapel Hill, North Carolina, and it turned out to be the right choice. They were still busy—Ellis worked long hours, a third son was born, and Ginny finished a master's degree as a legal librarian. But the bustle of their lives was framed around family. It was the center. One of their happiest times was a summer biking trip they took in the South of France. The memory of that time together is precious to them. Ginny's face softens as she recalls the five of them riding past magnificent scenery, with Dan, the youngest, bouncing along in the rumble seat of Ellis's bike.

Ellis and Ginny are very conscious of being role models and passing the torch of their strong marriage on to their children. They are both first-generation Americans on their fathers' sides whose Russian-American parents gave them a clearly defined sense of destiny. "Our parents were strong, loyal people, and very good role models," Ellis says fondly. "Two sets of parents really in love with each other. I believe that the lessons of a happy marriage get passed on to your kids. The same is true of unhappy marriages. I have a friend who had a very unhappy marriage. He and his wife had four children, then were divorced. He's on his second marriage. Three of his daughters are divorced, and you have to wonder if they didn't go into marriage with the thought, 'I can always get out of it if it doesn't work.' Of course, one thing that's different about today is that young people are living together before marriage."

"We weren't comfortable with it when our children did it," Ginny adds. "But we made a point of talking to them about commitment—pushing them, really, to make a decision. When our oldest son, Rod, and his girlfriend, Ann, decided to live together, we didn't like it, but we felt that if that's what they wanted, we had no power to change it. So we accepted it. But after they had lived together for about two years, I couldn't let it rest any longer. Rod was up at the house one day, and I asked him straight out, 'What are your plans?' And he said, 'No special plans.' I guess I came down fairly hard on him as a mother, and I said, 'You and Ann have made a significant emotional commitment to each other, and it's really like being married. I think you need to make a decision to go ahead and tie the

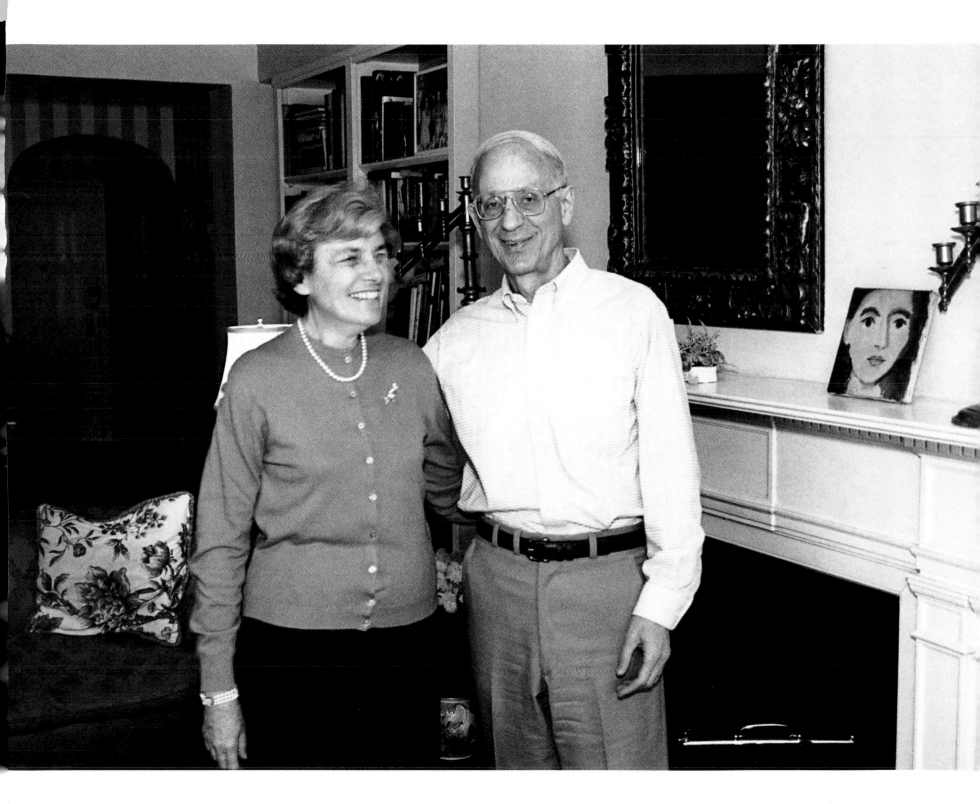

knot, if you're going to be together. If you're not going to do that, then you should go your separate ways.' They decided to get married."

"It's fish or cut bait," Ellis says. "If they can't make up their minds that it's going to work for them after they've been living together for a couple of years, when are they going to know? It's not magic. If they're waiting for the bolt out of the blue that says, 'This is the one,' it's not going to come. Romance is wonderful, but marriage is a decision."

The Roletts don't second-guess their decision. "I always wanted the experience of growing older together," Ginny muses. "Now we're enjoying it, and it's really wonderful."

TOM AND JOAN GEISMAR

That Special Someone

TOM GEISMAR DOESN'T often wear his heart on his sleeve, although the twinkle in his eyes and the mild blush that washes across his features when he looks at his wife speak of a man who takes great pleasure in his marriage.

Joan, on the other hand, has none of her husband's reserve. She is a force of nature as she sweeps into the room, her blonde hair flying. She is full of warmth, chatter, and laughter. "I'm volatile, he's steady," Joan explains, and it certainly seems to be true. She rains love and devotion on her husband, and he soaks it up. Joan grabs on to life with both hands and shows it no mercy, her energy a palpable current, while Tom appears to be riding the slipstream, comfortable and relaxed—no sudden movements.

With the exception of that one time, forty-one years ago—which Tom describes as "the last impulsive thing I ever did."

It was 1958, and a young Tom had just been discharged from the army, having honorably completed his service. A friend handed him a list of names and phone numbers—girls he should call for dates. "My friend thought I needed a social life," Tom says. "So I started going down the list, and the first girl on the list was Joan. I called, but the line was busy. So I moved on down the list." He pauses for effect, then deadpans, "A year later, I'd made it through the entire list, and was starting again at the top. This time I reached Joan, and I asked her out."

"I was very bubbly when Tom called," Joan says. "I was in a great mood, because a man I was interested in at that time had just invited me to visit him in Boston. I made a date with Tom for two weeks later."

It should be noted that the dating arena was a much different place in the late 1950s than it is today. As Joan explains, "We didn't have *relationships* then. We had *dates*. Many of them were blind dates—or, as we called them, fix-ups. I'd already dated plenty of men by the time I met Tom. It certainly wasn't unusual that I'd be getting ready to go off to Boston to meet one man while I made a date with another."

So Tom and Joan finally went out. Three days after that first date, Tom asked her to meet him for a drink. He stunned Joan when he blurted out, "Joan, I love you."

Joan was shocked. How could he feel so strongly so soon? They saw each other every day during the next few weeks, and Joan found herself falling in love with Tom. "I had dated enough men by then to know that Tom was very special," Joan recalls. "I didn't want to lose him. So, one night when we were out, I asked, 'Did you mean it that you love me? Because I love you, too.'"

They got engaged that night. Six weeks later, they were married.

"I must have been foolhardy." Tom chuckles, looking slightly embarrassed. It's also perfectly clear that he doesn't mean a word of it.

Still, it wasn't all marital bliss from that point on. "We didn't know each other very well," Joan says. "I went into a bit of a tailspin."

Part of the problem was Joan's youthful expectations. She had always envisioned married life as being a complete partnership, not just personally, but professionally as well. She expected to be involved in Tom's work. But Tom didn't see it that way at all. When they first married, Tom was well into a year of a creative partnership he'd forged with Ivan Chermayeff, a friend of his from graduate school. Tom and Ivan were graphic designers—a relatively new field in those days. They were among the first to promote the idea of trademark identity, now accepted as a core essential, not just for corporations, but for organizations and cultures. Today, their company, Chermayeff & Geismar, has an international reputation for imagination and excellence. Tom obviously has a gift for partnerships.

However, as Tom threw himself into his life's work, Joan remained uncertain about how she would make her mark in life. There wasn't too much time to brood about it. The couple's first child, a son, was born two years after they married, soon followed by two daughters.

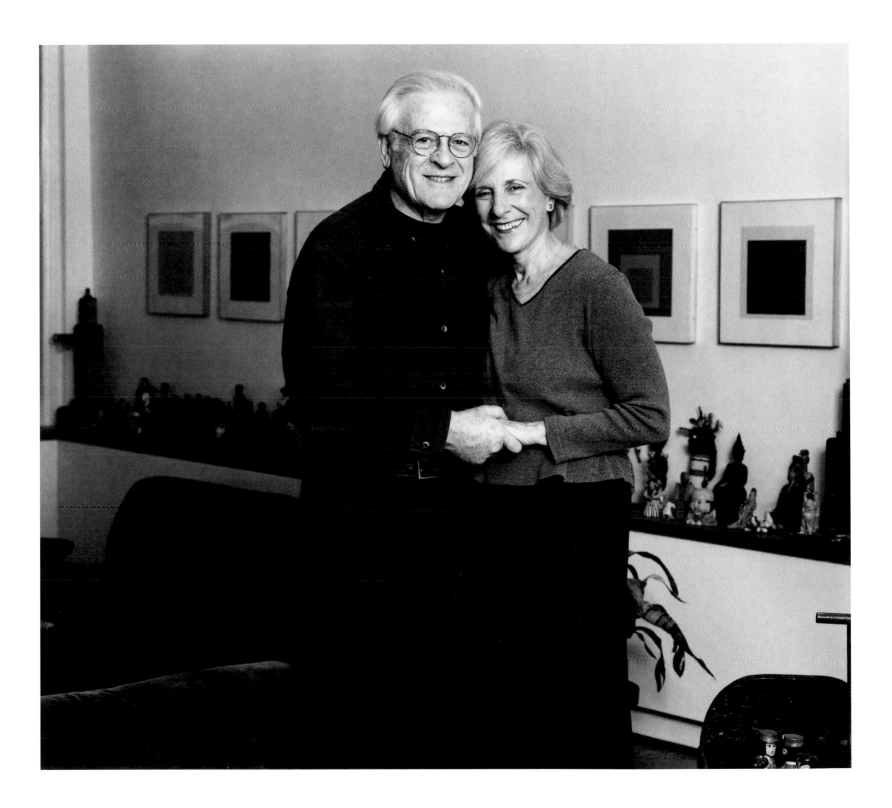

"I think I was a good mother," Joan says, catching Tom's eye for a silent affirmation. "I had a good marriage. But I knew I needed something more." When their youngest child was six, Joan returned to school to pursue a growing fascination with the field of archaeology. She went on to earn a Ph.D. at Columbia University, and is now an urban archaeologist, active in New York City's preservation movement.

Joan is grateful that she found her calling in life, because, she says, she doesn't know what might have happened to their marriage if she had not. "It's not right to make another person the sole source of your fulfillment," she states with conviction. "It puts too much pressure on a relationship to be the end all and be all, to provide everything someone needs. No relationship can really offer you that. I needed something that was as important to me as Tom's work is to him."

Tom and Joan readily agree that marriage hasn't always been an easy path for two people of such different temperaments. But they've accommodated each other so well for so long that they seem to be perfect complements to one another. When asked how they resolve their conflicts, Tom replies instantly, "I work. She talks."

His answer delights Joan. She bursts into peals of laughter, and gives Tom a hug. "I *adore* him," she says fervently. "After forty-one years, he still makes me laugh."

Tom shrugs, a little bit embarrassed as Joan fusses over him. Joan frankly admits that she wishes Tom would just toss his reserve off, and once in a while wear his heart on his sleeve. Not that she ever doubts his love. Still, it's always nice to hear the words. She loves it when Tom does let his feelings show. Recently they were at a dinner party. The hostess has a custom of offering a question and asking everyone at her table to answer it. On this occasion, the question of the evening was, "What have you been most passionate about?" When it was Tom's turn, he simply replied, "Marrying Joan."

Joan turns starry-eyed when she recalls the moment. Tom's face takes on that faintly burnished look as he ever so lightly blushes.

One more moment to savor in a lifetime of love.

PETER AND JANET SIMON

Putting Family First

Peter simon has one unshakable rule at the office: "When my wife calls, get me." It doesn't matter how important the meeting, how urgent the task at hand. He's always available to his family.

There is a lot of gratuitous talk these days about the importance of "putting family first," but for Peter, this isn't just an empty platitude. He really means it. In his position as cochairman with his brother William of the global merchant bank William E. Simon & Sons, Peter is frequently asked to serve on boards of directors and give talks to various associations. "I decline a lot," he says. "I made a conscious decision a long time ago that I wouldn't be driven by things that didn't benefit us as a couple and a family."

In Peter's mind, it isn't a difficult trade-off. At Hidden Pond Ranch, the Simons' sprawling country home in New Jersey, Peter and Janet have created a life worth living for themselves and for their four children. Like many couples, their personal styles are different—Peter is very patient and polite; Janet is more emotional and outspoken—but the combination works. "Peter is an equal partner in parenting," Janet says, "and it's a good thing. I'm Italian—I'll get upset about things. Then Peter arrives on the scene like this great calming influence."

Peter and Janet met when they were seniors at Lafayette College. At the time, Peter was dating another student, but the two became fast friends. "I was an A student," Janet laughs, "and Peter was struggling. I helped him. He also played a mean game of squash."

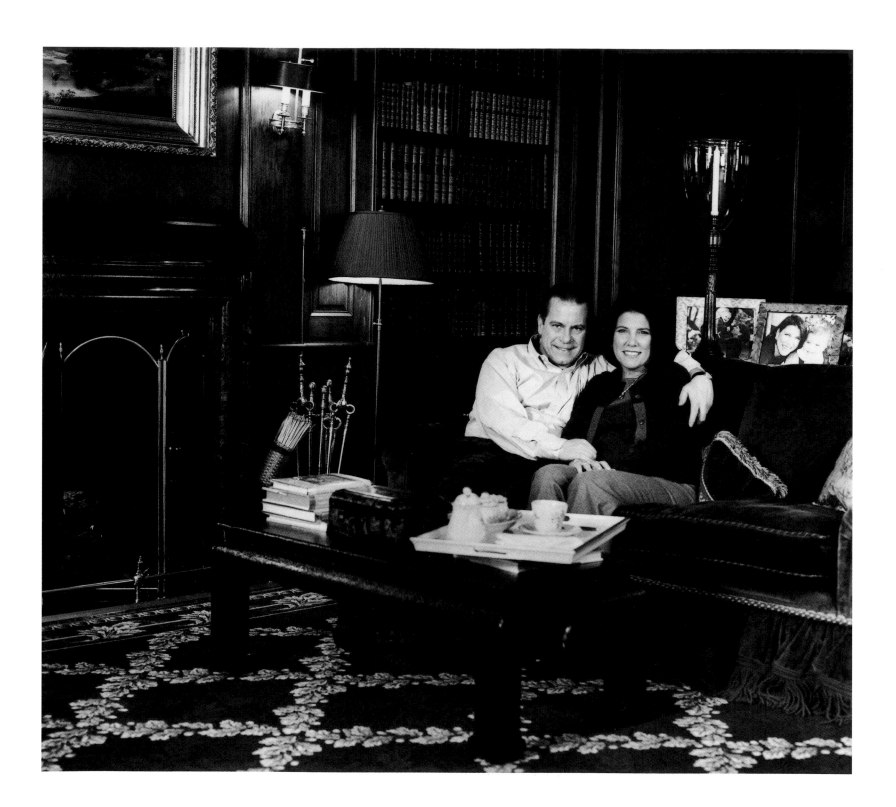

On paper, Peter wasn't at all the kind of man Janet would have pictured herself marrying. When they met, Peter's father, William E. Simon, was the secretary of the treasury. Appointed in the waning days of the Nixon administration, he had stayed on when Gerald Ford became president. As the chief spokesman for the administration on economic policy, Secretary Simon had an extremely high profile and was frequently in the news. Janet soon learned that Peter's family was not only influential but also wealthy. "I wasn't impressed by that kind of thing," Janet says, wrinkling her nose. "I thought rich kids were spoiled and distant. But Peter was so different than my picture. I was quite taken with him. He had long hair down to his shoulders, and he was very sensitive and caring. He was just so *nice*. I liked him immediately."

For his part, Peter thought his new friend was quite different from any woman he had ever met. She was so honest and direct. She said exactly what was on her mind. He loved that quality about her. He also thought she was beautiful.

The chemistry was there, but they didn't explore it until after Peter had broken up with his girl-friend. They both credit being friends first with the stability of their union today, after twenty-two years of marriage. "Physical attraction is a wonderful ingredient," says Janet, "but our relationship started out on a sound premise, and that has made the difference. We like being together, telling each other things. As I always say, if it's not happening in the living room, it's not going to happen in the bed-room."

They didn't originally plan on having four children, and for a time, it seemed that they might have none at all. Fertility problems plagued the early years of their marriage, and after nine years, they decided to adopt. They went on to adopt two children. Then, in one of those inexplicable miracles of nature, the fertility problems disappeared, and they had two more children, "home grown."

The cardinal rule of the Simon household is to never let grievances fester. "We don't drift," Peter explains. "If there's a problem, we talk it out, right then and there. When you let something go, it grows bigger."

Janet nods in agreement. "It's true. People go into marriage, and they expect their partners to automatically know what they want and need. They think their partners should be mind readers, and when they're not, they get angry and frustrated. Instead of saying, 'I need this,' they build the case against their spouse in their mind. It's ridiculous. I can't tell you how many times friends have complained to me

that their husbands forgot their birthdays or about some other slight. They place too much impor-tance on little things. They'll say, 'How could he love me if he didn't know how important this was to me?' I say, 'Tell him! Give him a clue.'"

For the Simons, paying attention, being present to each other, is a big part of the fun. "We talk on the phone twenty times a day," Peter admits, with an embarrassed chuckle. "It seems like a lot. . . ."

Janet beams, content. "What can I say? I have a saint for a husband. Peter is such a generous man. He gives me time and attention. Let's face it, a lot of men are not that much fun to live with. We have fun every day. I can't wait to see how much fun we'll have growing old together."

MORT AND JOAN HAMBURG

Mixing It Up

Mᴏʀᴛ ʜᴀᴍʙᴜʀɢ ɢᴏᴛ his first real inkling that he was marrying a rebel on his wedding day, when his bride appeared wearing a blue dress.

"I was horrified," he says with a grimace.

"I refused to be a bride," Joan counters, with no hint of apology.

Thus began a thirty-eight-year union that has never stopped being . . . well, an *adventure*. Joan calls the couple a mixed bag, with a shopping list of differences:

He's conservative. She will try anything once.

He's quiet. She's gregarious.

He's sentimental. She's practical.

He likes a schedule. She's spontaneous.

He's a worrier. She's eternally optimistic.

He prefers home and hearth. She's drawn to explore.

Normally, so many disparate ingredients would be a recipe for disaster, but the Hamburgs have managed to create from them a very tasty stew.

While their differences may be more visible on the surface, their common ground is steadier. Simply put, Mort and Joan are decent and generous people who agree about the important things. "Both of us wanted to leave a footprint on the world and make it better," Joan says. "We weren't about money. We were about family, children, loyalty, and a strong moral sense."

"Besides," says Mort, the sentimental one, "I just loved her from the first minute."

When the two met, Mort was a twenty-nine-year-old lawyer with a good firm in New York City. "I wasn't thinking about marriage yet. I wasn't making much money, and I wanted to be more established before I took that step," Mort says. "But one of the guys in the office, who had recently married, kept bugging me, and one day I told him, 'You find me a tall blonde, and I'll get married.'" Soon after, Mort's colleague showed up and shoved a piece of paper at him with a phone number scribbled on it. "Here's your tall blonde."

"He told me she'd gone to school with his wife, and she was terrific and had a great personality," Mort remembers. "And then he said she'd just written a book—*New York on $5 a Day*. I thought, my kind of woman."

Joan, however, proved a bit more difficult to pin down. When Mort called and asked her out for a drink, she told him, "I don't just go out for drinks." So Mort said, "Well, I hear you just wrote this book, *New York on $5 a Day*. Why don't you pick a restaurant?" She agreed to that.

"Can I meet you at the restaurant?" Mort asked. "My work schedule is very demanding." She said no, he had to pick her up at her apartment in the Village.

To his credit, Mort was undeterred. A happy thing, as it turned out. "She opened the door and she was beautiful, wearing a red dress, long blonde hair. I just loved her right from that minute."

Joan was different from any other woman Mort had ever known. "She was so lively, so interesting. She knew everything about New York. She wanted to travel. I had never talked to a woman like this."

It didn't take long for Mort to be sure about Joan. In his systematic way, he began planning for their eventual marriage—sooner, he hoped, rather than later.

Joan wanted to get married—someday. "I was in no rush," she says. "I'd graduated from Barnard, then had written this book, which did incredibly well. But I also was an actress, and I was in an off-Broadway troupe, and I was not particularly interested in getting married right then. Mort was very aggressive about getting married, though, and finally I said yes."

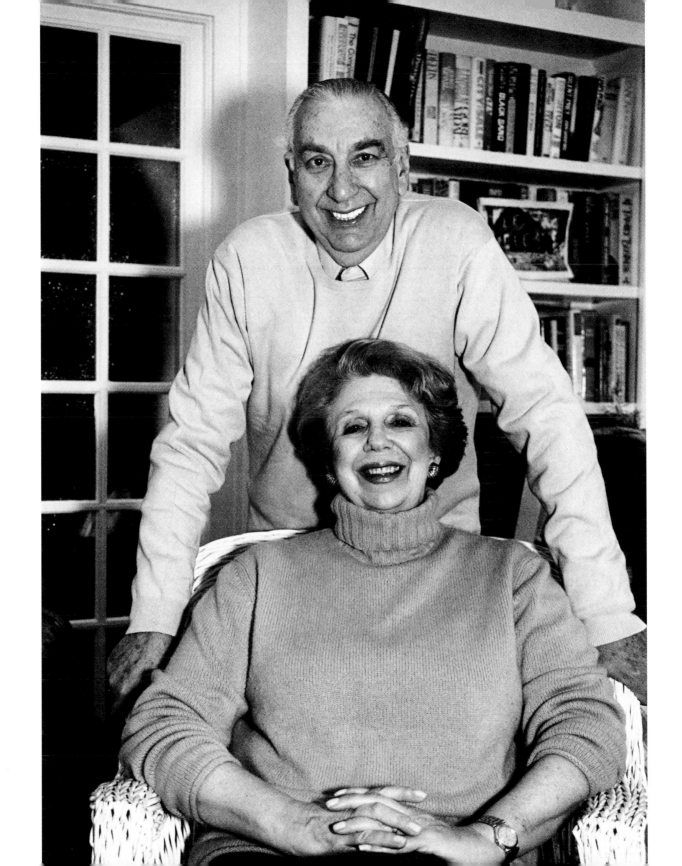

She warned him, though. I said, 'I've always been an adventurer. If there's a place to see, I have to go see it.' I never pretended to be something I wasn't. I always told him the truth about who I was and what he could expect from me."

"Except for the blue dress," Mort reminds her. "And inviting all of your cousins on our honeymoon."

Well, she didn't exactly *invite* them. A cousin of Joan's had a beach house in Westhampton, and he offered it to the newlyweds for a few days. "The day after we arrived, her cousin appeared," Mort says. "And then other cousins. It was a crowd."

"That's the way they were," Joan explains. "When we were kids, the door was always open, and— "

"And," Mort interjects, "we finally had to leave the house and move into a bed and breakfast."

That was just the first week.

From the outset, Mort and Joan had to come to terms with their different expectations about marriage. The adjustment wasn't always so easy, especially for Mort. People bring to marriage the baggage of their childhoods, and Mort's early life had been difficult. He had not experienced the nurturing children need to feel secure. For him, marriage represented that safety and certainty, but he had to get used to Joan's ways. She, too, was a product of her upbringing, where family meant being surrounded by other people, and learning to be self-sufficient—but always against the stable backdrop of love. "I didn't require a lot of care and feeding," she says. "I'm a caretaker, though, and I grew up in a generation that stressed you must take care of your man. So the other side is, I spoiled him. And I enjoyed spoiling him."

What ultimately made the marriage work was a remarkable capacity on both sides for compromise, and a willingness to shift gears when needed. Mort may have been conservative, but he was by no means rigid. He delighted in family life and had a knack for parenting. Joan warms to the topic of Mort and babies. "I love kids, but I was not great with the babies," she admits. "I didn't have the patience. But Mort was unbelievable. By nature he's so organized and methodical, and that's exactly what was needed."

For her part, Joan was supportive when Mort wanted to leave his solid law firm and join some colleagues in opening their own firm. It was a risky venture, and Joan wasn't sure it was a good idea, but if that's what Mort wanted, she was for it. Later, when Joan began a career in radio, Mort was

behind her, pitching in to take their children to school and pick them up. More recently, when Mort decided to leave the law and pursue his lifelong passion for photography, Joan once again encouraged him to go for it.

This selfless give and take has been the hallmark of their marriage, providing a ballast during the difficult times. And there *were* difficult times. Joan is not one to gloss over the hardships. She's honest and straightforward—a quality that is part of the appeal she has for the over one million daily listeners of *The Joan Hamburg Show.*

"People don't like to admit it," she says, "but every marriage has those rough times when you think, 'I can't deal with this. How am I ever going to get through this?' But you get through it. For me, that's what marriage is. The *institution* of marriage. It holds you to your promise. It requires loyalty. You step past your difficulties and move on. Today, so many couples think that if they get married, they'll live happily ever after, and when they have problems, they say, 'I'm outta here.' They don't think of what's involved in really being a partner—really sharing your life. After thirty-eight years, we may not have the same moments of excitement, but we have the comfort of familiarity, and the sense of truly knowing the other person. It's a very deep thing that's hard to put into words, but I think everyone wants it."

"It's love," Mort says. "Love and commitment are interchangeable. If you're lucky enough to find someone that you really love, and you're committed to that person, that's the important thing."

Joan smiles at her husband affectionately. "You're the sentimental one. But, you know, looking back sometimes, I'm amazed. I can't believe it's a lifetime. It's history. We have roots. We've created a family tree, a gift to the next generation. Out of all these differences."